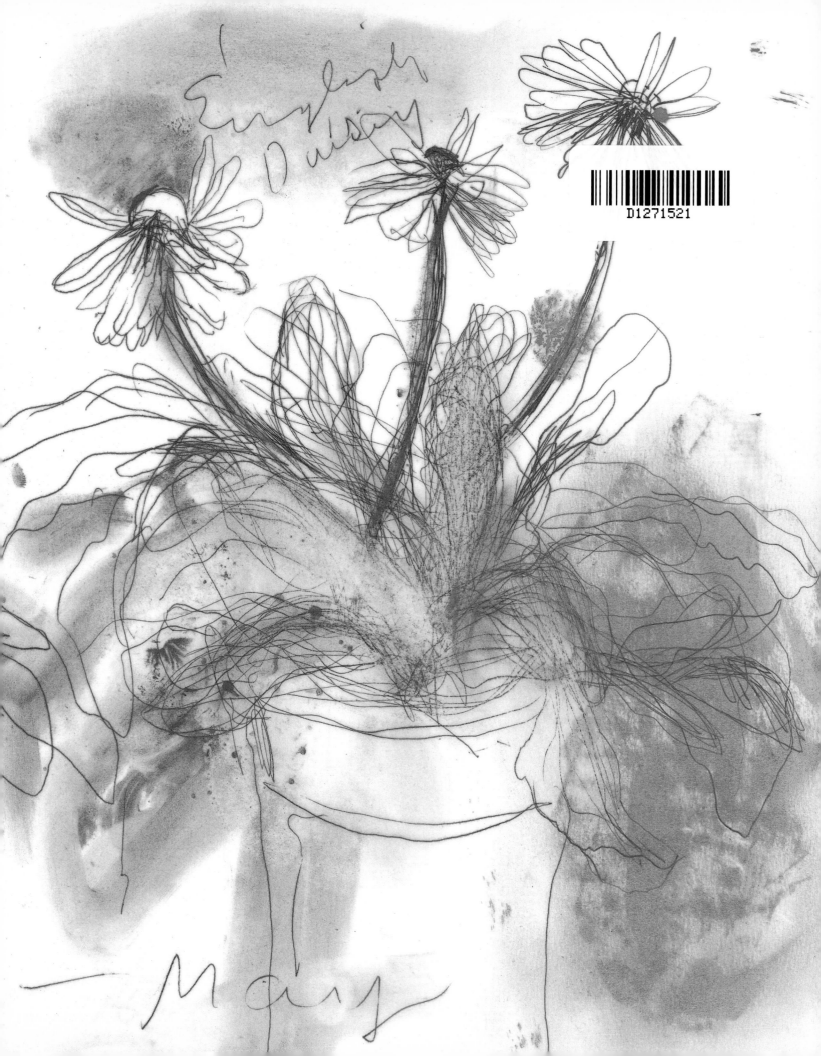

English Daisy

D1271521

Jim Dine F L O W E R S A N D P L A N T S

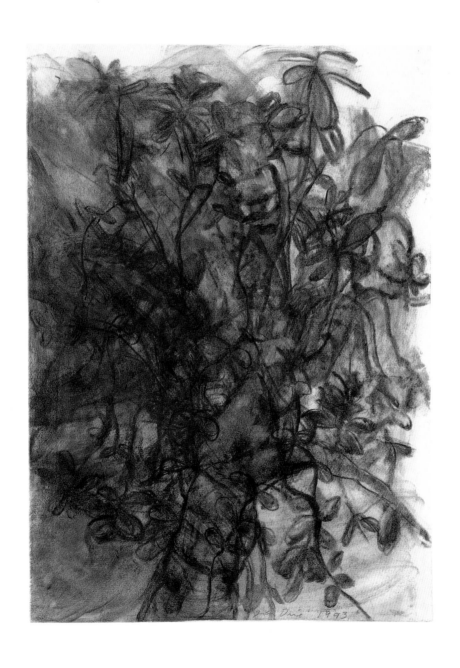

Jim Dine FLOWERS AND PLANTS

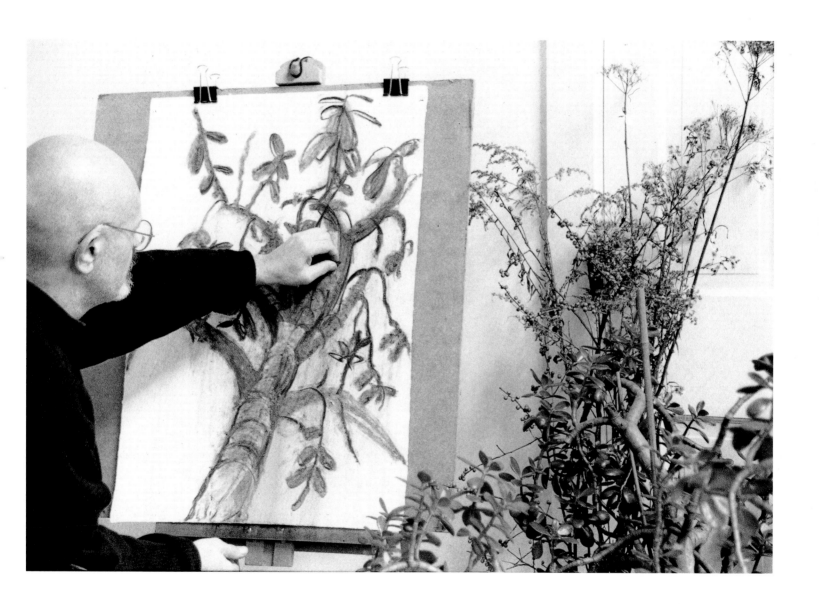

Essay by Marco Livingstone

HARRY N. ABRAMS, INC., PUBLISHERS

Editor: Phyllis Freeman
Designer: Elissa Ichiyasu

LIBRARY OF CONGRESS
CATALOGING-IN-PUBLICATION DATA
LIVINGSTONE, MARCO.
JIM DINE FLOWERS AND PLANTS /
BY MARCO LIVINGSTONE.
P. CM.
INCLUDES BIBLIOGRAPHICAL REFERENCES
AND INDEX.
ISBN 0–8109–3214–8
1. DINE, JIM, 1935–
2. BOTANICAL ILLUSTRATION—UNITED STATES.
3. FLOWER PAINTING AND ILLUSTRATION—
UNITED STATES.
4. BOTANICAL ARTISTS—UNITED STATES—
INTERVIEWS.
I. TITLE.
QK98.183.D56L58 1994
581′.022′2—DC20
[B] 93-25858

HALF TITLE: *Christmas Crassula.* 1993.
CHARCOAL ON PAPER, $31\frac{1}{4} \times 22\frac{1}{2}''$.
PRIVATE COLLECTION, LONDON

TITLE PAGE: JIM DINE WORKING ON
Christmas Crassula. 1993. PHOTOGRAPH:
NANCY DINE

Tomato plants in October #2 [illegible] June 1997

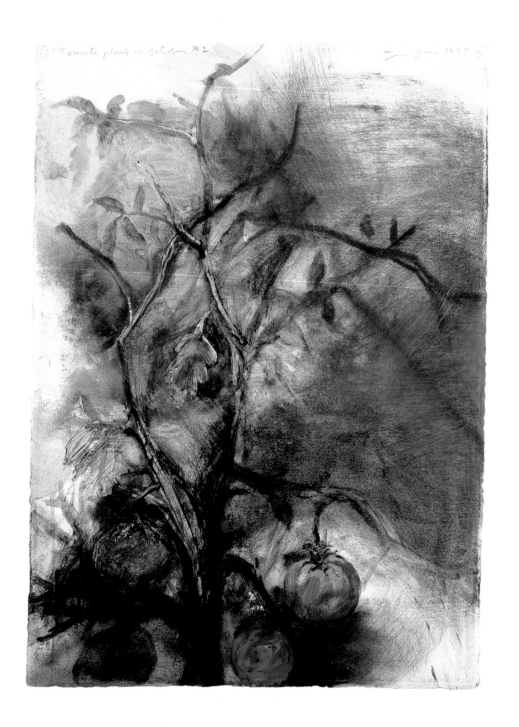

CONTENTS

Tomato Plant in October No. 2. 1993. CHARCOAL,
PASTEL, AND WATERCOLOR ON PAPER,
30½ × 22¼″. COLLECTION NANCY DINE

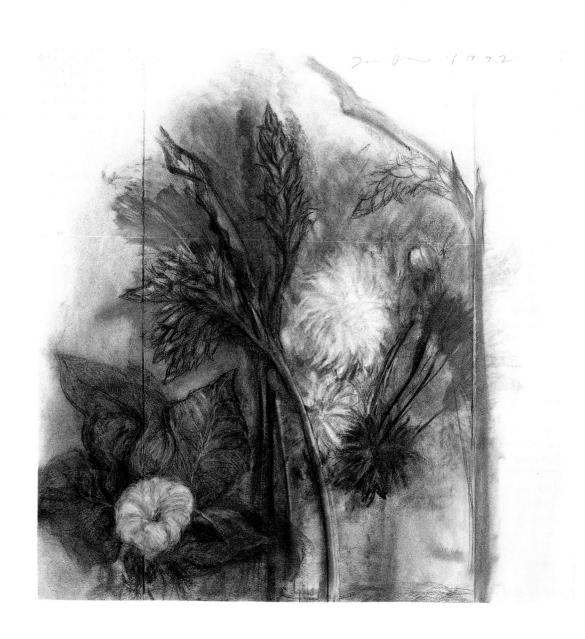

ACKNOWLEDGMENTS

Jim Dine has been well served by other writers, and in preparing this text I was inspired, in particular, by a more general study, *Jim Dine Drawings,* published by Abrams in 1985 with an illuminating text by my esteemed colleague Constance W. Glenn. My main debt, however, is to the artist himself, for the generosity with which he has given his time and for the honesty and lack of pretension with which he has consistently spoken to me about his work. The more formal interviews which he granted me specifically in relation to my research for this book were of inestimable use, supplementing the more casual conversations we have had about his art since I first wrote about him in 1986. The artist Blake Summers, who has worked as Dine's assistant since 1982, in addition to having works photographed for the book, also gave me the benefit of his astute observations, which brought to my attention subtle aspects of the drawings that I might not otherwise have noticed. Finally, the staff of The Pace Gallery, in particular its vice-president Douglas Baxter, have very kindly made material available to me in the course of my work on this and other projects concerning the artist.

Marco Livingstone

Ginger and Other Plants. 1992. CHARCOAL, CHALK, AND PENCIL ON PAPER, 30½ × 30¾″.
THE PACE GALLERY

for Millie & Me, Xmas 1978 Aloe Vera Jim Dine 1978

A JOURNEY INTO NATURE

Marco Livingstone

The metamorphosis of Jim Dine since the 1970s, from an artist-scavenger and manipulator of found objects and emblematic images into a keen observer of nature for whom draftsmanship serves as the most precise tool of expression, is most vividly manifested in the studies from life of botanical and human forms through which he decisively altered the course of his art. However surprising this evolution away from modernist vanguardism in favor of the centuries-long achievements of the mainstream European tradition, it has been expressed consistently through the particularities of the handmade mark in relation to a range of motifs that he has made his own through a process of constant reexamination.

The grafting of nature onto Dine's art has allowed it to flower in unexpected ways, but it has also transformed it in certain respects into an altogether different species. Many who admired the insouciance and anarchic spirit of his youthful production have found it difficult to follow him in this reinvention of himself, through a slow process of reeducation of the eye and hand, as a great draftsman. It would be childish to attribute such responses simply to envy of his prodigious skills; Dine's reconsideration of his priorities, involving a rejection of modernist provocation for its own sake, can seem to some like nothing short of betrayal.

In Dine's early work it was through the banal realities of urban life in our industrial age that he initially gave form to emotions and to his reveries about the process of creativity, leading him to be identified first with the Junk Art movement of the late 1950s and then with the origins of Pop Art at the beginning of the following decade. Some of his most memorable images of that period were of objects wrenched forcefully from their pedestrian context and inserted, with a parallel bluntness, directly into the fabric of his art; such is the case with the paint-splattered clothes transformed into the

self-portrait image of *Green Suit*, 1959 (fig. 1), or with the ordinary bathroom sink stuck squarely onto the center of one of his most notorious works three years later, *Black Bathroom #2*, 1962 (fig. 2). Gradually Dine gravitated to certain signature motifs, such as the symmetrical Valentine's Heart (fig. 3) or the self-portrait robe (fig. 4), that were both immediately recognizable and sufficiently generalized to bear a variety of associations and moods. However emphatically he has rejected his presumed alignment with Pop Art, he has continued to call upon both these strains of the art produced in his formative years: his appropriation of tools and other actual objects of everyday use as extensions of the human hand, and his reliance on an essentially enclosed system of motifs.

The decision to begin working from life, arising from a combination of circumstances and influences, entailed for Dine a move not only from contemporary urban to a more timeless natural imagery, but also by necessity a transition from the abstract to the particular. Instead of presenting a system of interchangeable signs—including the actual object, its name or its image in various forms, both handmade and mechanically replicated—Dine began to dispense with such distancing devices in order to represent as vividly as possible the particular person or life form with which he was in communion.

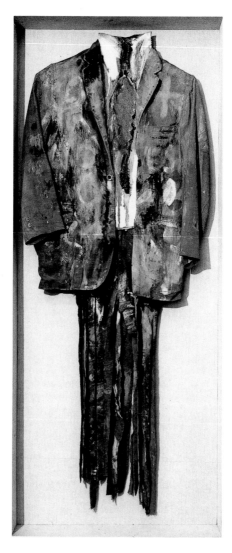

1. *Green Suit*. 1959. OIL AND CLOTH, 65⅝ × 28¾″. COLLECTION THE ARTIST

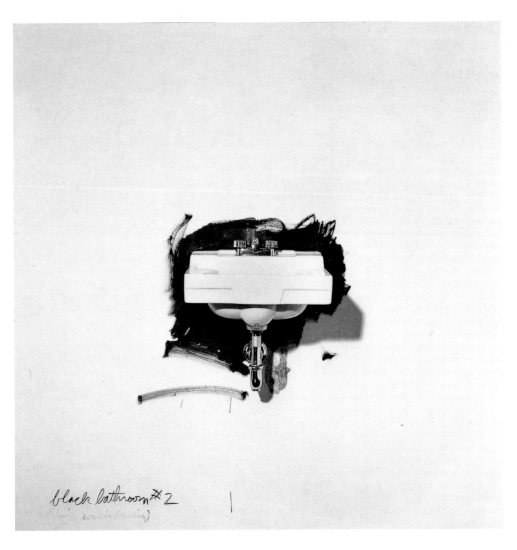

2. *Black Bathroom #2*. 1962. OIL DRAWING AND CHINA WASHBASIN ON CANVAS, 72 × 72″. ART GALLERY OF ONTARIO, TORONTO

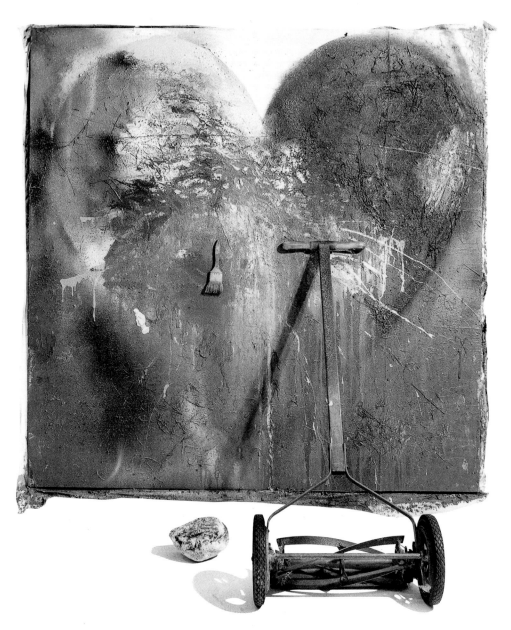

3. *Coming in the Sun.* 1971. ACRYLIC ON CANVAS
WITH OBJECTS, 74 × 77″. COLLECTION BYRON
AND EILEEN COHEN, MISSION HILLS, KANSAS

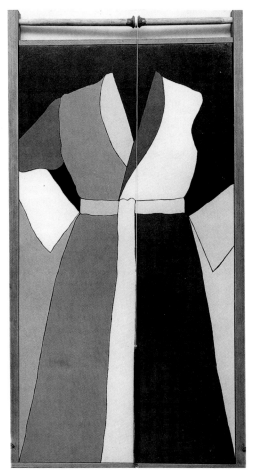

4. *17-Colored Self-Portrait.* 1964. OIL, METAL,
WOOD, AND STRING ON CANVAS, 69 × 37″.
ESTATE OF MYRON ORLOFSKY

5. FROM THE PORTFOLIO *Thirty Bones of My Body.* 1972. DRYPOINT, 30 × 22″

This is not to say, however, that he merely put a mirror up to nature, for he makes a point of demonstrating how the presence before him has been filtered through his own consciousness, through his feelings for that person or thing, and modified by the process by which it has been reshaped. Conversely, however descriptive the marks in his nature studies or life drawings may appear, they remain as self-sufficient, and therefore as fundamentally abstract, as those in his earlier art.

Dine's images of the 1960s and early 1970s were, of course, precise in their own way: every tool, for instance, whether painted, drawn, etched, or simply attached to the surface as a found object, has a clearly defined identity as one of many possible designs for a general class of object. When reshaped on the surface by Dine's hand, they are treated with the same sensitivity to their individuality that he would later apply to people and to plants, to the extent that they sometimes take on anthropomorphic qualities: witness the portfolio of thirty drypoints issued in 1972 as *Thirty Bones of My Body* (fig. 5), each representing an ordinary instrument as fleshy and covered in hair, or the set of four lithographs published in the same year, *Flaubert Favorites* (fig. 6), in which images such as a wrench and an electric fan are accompanied by handwritten captions identifying them as literary characters. Artifacts made by machines guided by human minds are thus presented as stand-ins for the people who brought them into being. In such works Dine was readying himself for one of his riskiest and most audacious moves as an artist: that of working again from nature itself, without the mediation of pictorial devices dependent on irony and metaphor.

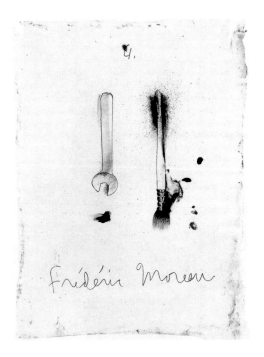

6. *Flaubert Favorites (Edition A): Frédéric Moreau.* 1972. LITHOGRAPH, 26 × 20″

Life drawing had formed part of Dine's training as an artist during the 1950s, and he had only recently begun to master its basic principles when his acceptance into the avant-garde fraternity around 1960 caused him to abandon the activity for more than a decade. In the intervening period he could see no way of producing such drawings, even privately, without compromising his position, but when he did eventually decide to begin drawing again from the model and from the motif, it was with a real conviction that he had found "a new way to express myself" and that "it was an admirable thing to do." His excitement was such that he gave no thought to the possibility that in returning to this activity he might be jeopardizing his historical position:

7. *Self-Portrait.* 1958. CHARCOAL ON PAPER, 20¾ × 18½". COLLECTION THE ARTIST

It was more comfortable doing this. This spoke to me and called for me to do it. I was called to use my powers that I was born with, rather than to sit on my hands in the name of a movement or a doctrinaire point of view or Minimalism or whatever it is. It's not me. I discovered myself as a Romantic artist at that point, and never looked back from that.

I couldn't do it in college, I couldn't make my hand do it. I remember I went for about a semester to the Boston Museum School in the mid-fifties, I was probably nineteen years old. I simply couldn't do what they wanted me to do. It was an academic place. I couldn't sit there in front of the model, I couldn't do any of that. I only wanted to make big expressionist things that didn't require me training myself to do anything. It was more like just an outpour of energy. But at Ohio University, in my last two years there, a man came to head the school called Frederick Leach, who had been trained academically, and who very much turned me on to Old Master drawings. And I made a few drawings after Fra Bartolommeo, and I made a few drawings of Nancy [Dine's wife], trying to do it properly, and I did it. I realized then that I could do it. And then I made some self-portraits [fig. 7], too, but not a lot. And then I stopped until the mid-seventies. That's when I really did it full-blown.[1]

9. *The Nurse.* 1975. CHARCOAL, OIL, AND
CRAYON ON PAPER, 40 × 30¼″

8. *Study of Richard Cohen in Vermont.* SUMMER
1971. PENCIL ON PAPER, 3½ × 3⅝″.
COLLECTION THE ARTIST

In an interview conducted in 1976, at the time that he was reinventing himself as a figurative artist, Dine recalls that it was in Vermont in the summer of 1971, a year after moving there, that he again found himself drawing the human face from life. Encouraged by his cousin Richard Cohen, a carpenter who also painted and took an avid interest in the art of the past, he began drawing every evening, using his cousin and his sons as models and in turn being drawn by them (fig. 8).[2] He gave himself fully to life drawing as a discipline, however, only a few years later (fig. 9), largely under the impact of his friendship with the American painter R. B. Kitaj, whom he had got to know while he was living in London from 1966 to 1970 and with whom he generally stayed during his frequent return visits in the mid-1970s.[3] Dine readily admits that it was partly to please Kitaj that he set himself on this course, "because he was so persuasive that this is what I should have been doing . . . and he was absolutely right." Suddenly he could see a way of making direct use of the discoveries that could be made through direct observation, as had been the case for many of the artists he had most admired from the past: Alberto

Giacometti and beyond him a lineage of great draftsmen that included Dürer, Leonardo, and Rembrandt; Ingres, Van Gogh, and Cézanne; Picasso and Matisse.[4]

It was through his friendship with the Scottish painter and botanical artist Rory McEwen, however, that Dine came to embrace plants and flowers as a fitting subject for his art. They met each other at a party in New York in the spring of 1965, and they became and remained intimate friends until McEwen's death in 1983, after suffering from cancer.[5] At first Dine knew McEwen only as a painter of abstract pictures, which interested him very little, and it was only two years later that Dine first saw examples of the meticulous portraits of leaves and flowers painted by McEwen with watercolor on parchment or in etchings (figs. 10 and 11).

11. RORY McEWEN. *Pomegranate*. 1972. ETCHING, 22 × 27″

10. RORY McEWEN. *Violets*. 1972. ETCHING, 27 × 22″

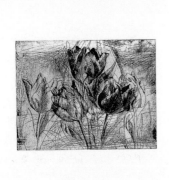

I was astounded, and it was like his secret life then, when he was trying to be this modern artist. His approach he learned from Wilfrid Blunt, and it's based on Redouté, or . . . on anonymous eighteenth-century botanical illustrators who would use watercolor on parchment, which was his method: the thinnest little brush and watercolor on stretched parchment. He was a throwback to the eighteenth century, he was a true amateur. He could do so many things. He was a musicologist, a guitar player, a botanical illustrator, a hunter, a naturalist. We had long conversations, and he pointed out how to observe things closely; that word never came into my vocabulary until I met him. At the end of his life he was doing gorgeous things. He was getting great, because he was accepting more what he was.

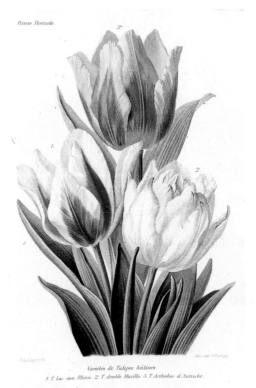

13. G. SEVEREYNS, AFTER P. DE LONGPRÉ. *Varieties of Early Tulips.* 19TH CENTURY. ENGRAVING AND WATERCOLOR

Although Dine's concern with the process of drawing as one of constant correcting and reinventing made it impossible for him to emulate McEwen's precise and almost photographic technique, he clearly responded to the attitude toward observation revealed in a posthumously published statement of McEwen's intentions: "So I paint flowers as a way of getting as close as possible to what I perceive as the truth, my truth of the time in which I live. This mostly means looking, looking and thinking, then painting, and then thinking how much better the painting could be."[6] It was, moreover, through McEwen that Dine became acquainted with the engravings of the great botanical illustrators who had set the terms for McEwen's work more than two hundred years earlier. Among the distinguished names cited by Dine are Pierre-Joseph Redouté, Nicolas Robert, Carl Linnaeus, Georg Dionysius Ehret, and Robert Thornton, but he has also looked extensively at the work of anonymous illustrators in the same vein.

For some years, beginning in the 1960s, when loose prints could still be bought cheaply in antique shops and market stalls in London, Dine collected such material,

sometimes using it directly, in place of a living plant or flower, as a model from which to draw. In fact, one of the earliest appearances of flower imagery in Dine's work—in the 1974 series of etchings *Self Portrait in a Ski Hat,* culminating in *Self Portrait in a Ski Hat (Obliterated by Tulips), Fourth State* (fig. 12)—was based on an obscure nineteenth-century chromolithograph that he happened to purchase (fig. 13). In its profusion of blossoms it also recalls one of the most famous of all botanical prints: R. Earlom's mezzotint of tulips after a painting by Philip Reinagle, as published in Robert Thornton's *The Temple of Flora* (fig. 14).

Dine's interest in flower imagery emerged first in his prints because, he recalls, "I saw in hard-ground etching the way to be precise in rendering the flowers that came from these steel engravings." When making prints for some years afterward, it seemed natural to Dine to work not from life but from other prints, in which the forms had already been translated into line. Of this early instance, Dine says simply: "It stood still for me, so I could invent from it." He continued to avail himself openly but respectfully of such sources, notably in the series of nine mixed-medium etchings published in 1978 as *A Temple of Flora* (fig. 15) in homage to the publication by Dr. Thornton to which they make direct

reference, and again in 1984 in the seven watercolor studies (figs. 28–34) and bound book of twenty-nine drypoints and engravings published under the title *The Temple of the Flora.*

The obliteration of Dine's features by flowers in the self-portrait etchings made in 1974 speaks tellingly of his identification with plants almost as an extension of himself. It was not that he consciously intended such an equivalence between natural images and his own identity, particularly in this first instance, where the sequential addition of blossoms served to focus attention on the various states of the print and therefore on the process itself.

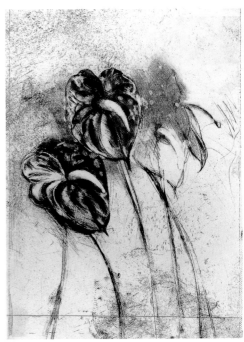

15. *Anthurium,* FROM *A Temple of Flora.* 1978. ETCHING, SOFT-GROUND ETCHING, DRYPOINT, PHOTOGRAVURE, AND ELECTRIC TOOLS, HAND-COLORED WITH WATERCOLOR AFTER EDITIONING, 23¾ × 17¾"

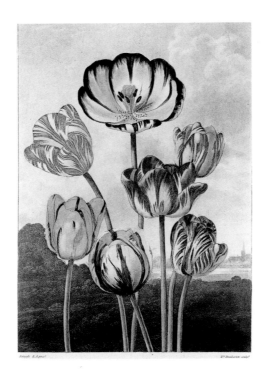

14. R. EARLOM, AFTER PHILIP REINAGLE. *Tulips.* 1798. ENGRAVING AND WATERCOLOR, 10 × 7¼". FROM ROBERT THORNTON'S *The Temple of Flora,* 1799–1807

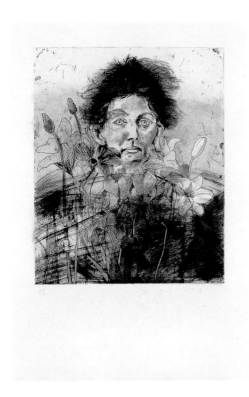

16. *Nancy Outside in July VI: Flowers of the Holy Land.* 1979. ETCHING, SOFT-GROUND ETCHING, DRYPOINT, ENGRAVING, AND ELECTRIC TOOLS, 35¾ × 24⅞″

Nor did he regard plants as functioning as metaphors for himself in quite the same manner as other motifs that he had made his own, such as tools and hearts. Nevertheless he says of all his art:

I'm presenting evidence of my own personality. In the end, that's what I'm doing. That's all I can ever get to. If my personality is revealed in a plant drawing . . . it would be just the emotion and the way I felt when I depicted it at that moment, that day, or as the days go on the building up of layers like the unconscious. The reason I've made plant drawings all my life is because I'm in love with the plant. I draw, and it's a way to express my feelings at that moment, and also a way to express my feelings about the plant. Both things.

Once they emerged in Dine's art, flowers began to sprout everywhere, often again in front of figures, for which they seem to serve almost as attributes in the manner of traditional depictions of the saints. Such is the case, for example, with several of the *Nancy Outside in July* etchings of 1978–81, in which the artist's wife peers through ever more luxuriant foliage (fig. 16).

I combined Nancy with the flowers because she's a woman who has a great, deep connection with plants. Probably her major soulful connection to living things is to flowers, although she's pretty good at growing vegetables, too. But what she can do with flowers is extraordinary; she can distort the flower itself when she arranges it, for instance. I've seen her pull at roses . . . and enhance them in some way. She has some physical connection that I've never seen anyone else have, including professional gardeners. . . . I wouldn't say she has a green thumb, it's not that. It's that she has a physical connection to this growing thing. . . . I've observed it for thirty-five years and it has inspired me, it has inspired me about plants.

In the summer of 1971, shortly after moving to a farm in the rugged landscape of Vermont, Dine had built a large deck onto the back of the house, which Nancy filled with succulents, annuals, and other plants; they also planted a vegetable garden. Nancy, though not an artist, began drawing these plants and flowers,

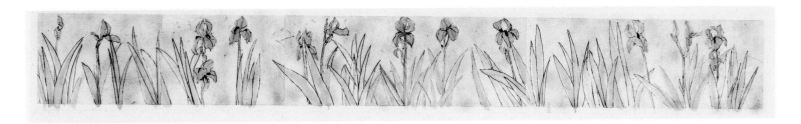

17. *Rachel Cohen's Flags, State I.* 1979. DRYPOINT
WITH HAND-PAINTING, 17¾ × 138″

encouraged by her husband to express herself through the medium and rendering them in a perhaps primitive way that nevertheless clearly exerted a charm on Dine. Even in his childhood, it was the women in his family who had demonstrated a particular connection with plant life:

My grandmother who raised me was very much in touch with the earth. Our climate was reasonably mild where we lived, and in the springtime, when the earth warmed up, she would take a tomato from the refrigerator and go outside and squeeze it in her hand and put it in the ground, and we'd have tomato plants. She boiled up my grandfather's cigars to make an insecticide to keep the aphids off the peonies.

That's my first connection with plants and flowers. My mother, too, had some feeling for flowers. She was a flower painter herself in college, in art college. She was trained by someone who had gone to Columbia Teachers College, where Georgia O'Keeffe went. They painted a certain way that was based, I guess, on the Arts and Crafts Movement. A "posterizing" of things.

Dine later dedicated to his grandmother a frieze of irises in the form of drypoints, *Rachel Cohen's Flags, State I,* 1979 (fig. 17). Family connections also help account for what is perhaps the earliest manifestation in his art of these botanical interests, the set of eight prints that he made in 1969 under the collective title *Vegetables* (fig. 18). As in earlier works, the images are presented mostly in the form of found objects, in this case of photographic images of the type printed on seed packets; only occasionally are they depictions wrought by his own hand, their identity sometimes confirmed by the accompaniment of a handwritten label.

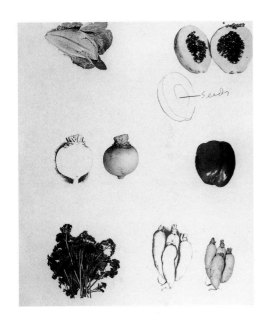

18. *Vegetables VIII.* 1969. LITHOGRAPH AND
COLLAGE, 17¾ × 16⅛″

19. *Untitled.* 1973. GRAPHITE AND COLLAGE ON PAPER, 23¼ × 30¾″. COLLECTION THE ARTIST

Dine says now that it was out of expediency, out of a lack of certainty about his skills as a draftsman, that he continued to rely so heavily on ready-made images and linguistic signs. The urge to depict was there, but it would take him some years of practice before he would feel sufficiently confident of his powers of observation and manual dexterity to embark on the series of plant drawings that are the subject of this book.

The precise volumetric rendering in pencil of a single plant, as an almost sculptural form, that characterizes Dine's first fully realized plant drawings, such as *The Jade Plant,* 1976–77 (fig. 53), is very similar to the technique that he had employed a few years earlier in drawings of tools. One such tool drawing, *Untitled,* 1973 (fig. 19), characteristic in its building up of the surface by means of collaged pieces of torn paper, includes among these fragments two images of flowers: one of them inserted ready-made, pointing to the range of printed and photographic sources to which he would continue to refer, the other rendered by hand through a combination of expressive smudging and descriptive outline.[7]

The decision to work in such a concentrated fashion directly from life may have appeared shockingly sudden to Dine's audience, because of the way in which the new direction was suddenly made visible in his exhibitions, but it was clearly a gradual process, a natural progression. The thick stem and branches of *The Jade Plant* are treated almost like an upraised arm and hand with aged, gnarled joints. Just as Dine continued in his plant drawings to explore processes that he had first devised for other subjects, so he still saw reminders of the human form—unconsciously, perhaps—in everything he drew.

20. *Lithographs of the Sculpture: The Plant Becomes a Fan.* 1974. LITHOGRAPH (THIRD IMAGE FROM THE SUITE OF FIVE), 36 × 24″

Throughout the 1960s and into the 1970s he had treated tools as stand-ins for the body and other forms of life; as far back as the early 1960s, in a group of drawings recalled more than a decade later in his *Lithographs of the Sculpture: The Plant Becomes a Fan*, 1974 (fig. 20), he had even proposed a metamorphic interchange between animate and inanimate forms. Now, without suggesting that he knowingly or explicitly wished to present plant forms as substitutes for the human anatomy, the interconnections between different forms of life seem almost inevitable, especially in his paintings and drawings of the sinuous forms of tree trunks rendered as equivalents to fleshy torsos (fig. 21).

I always thought that the close examination of plants, by looking, gave me a great deal of pleasure, not unlike the close examination of the human body. But I never thought of it metaphorically speaking. When there has been distortion ... on a great scale, it has only been because the emotion about drawing, not necessarily about the plant, has taken over. Or that

I've not been able to get it right, I've not been able to get it convincing, reinventing, rebuilt the way I like to do it. So that I would scribble and scrub it in some way, and distress it and beat it up until it came back up.

Drawing a plant, for Dine, is no different from drawing a human model: "Except that, of course, my plants are around longer. They'll be here all day every day, and even though they're growing or wilting or dying, they're reasonably there for the next week or so, say. So you do have it longer, so that gives you more time to observe." He remarks, not entirely in jest, that he could be arrested if he subjected a person to the kind of intense scrutiny that he applies to plants.

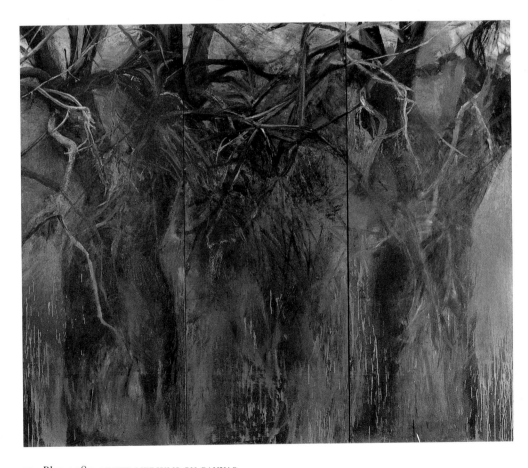

21. *Blue*. 1980. MIXED MEDIUMS ON CANVAS (THREE PANELS), 80 × 96″. COLLECTION THE ARTIST

They are, in a sense, ideal models: they don't move much, they don't get tired, and they don't talk back. The activity also provides a useful contemplative release from his other work. "I wanted to sit with the plant," he explained as he worked on a new group of these drawings at the end of 1991. "After eight months of working on sculpture and painting in a frantic way, it's quite a good thing to come back and look at nature closely, quite healing."

Given that Dine uses plants and flowers essentially as a starting point for pictures that must then obey their own internal logic and compulsions, rather than as specimens to be rigorously documented, his work falls more within the tradition of flower painting than of botanical illustration. However rigorously observed the plants may be, for Dine to be satisfied with the result the marks through which their presence is called into being must also be self-sufficient as structural elements of the drawing. Nevertheless, the explicit references to other art in his botanical pictures are always to "scientific" images, usefully precise as portraits of particular specimens already translated into two dimensions, rather than to the work of the painters he admires, which would already be too layered with interpretation to serve him in this way. For example, he regards as sublime the flower paintings of the late nineteenth-century French painter Henri Fantin-Latour, but says that what he really aspires to are the studies of nature by artists such as Leonardo or Dürer, whom he refers to as "the most devout artist I know."

For Dine there is an unquestionable religious dimension, on the most basic level of communing with nature, to his images of plants. "My botanical drawings exist because of my fascination and reverence for nature, just that. The miracle that these things exist, that they have been made by God. That interests me more than anything." Nevertheless, he sweeps aside the historical associations of flower images with themes of mortality. The very origins of the flower piece as a distinct genre in the Low Countries during the sixteenth and seventeenth centuries, as is well known, were closely linked to the *vanitas* theme, to the sense of the transience of all life. In Japanese culture, too, aspects of nature, such as cherry blossoms, are appreciated for the heightened awareness they engender of the ephemeral quality of beauty, though of course without the Christian moral overtones. No such symbolism is sought, however, by Dine. If he shows the stems of a plant drooping and wilting, as in his potted-plant drawings of 1978 (figs. 22 and 23), or a blossom opened wide to the point that its petals are about to fall, as in *Tulips,* 1979 (fig. 24), it is not in order to make a point about the cycle of life or the imminence of death. It is simply that he wishes to show the plants in the precise state in which he witnessed them, without idealization, in their glorious particularity.

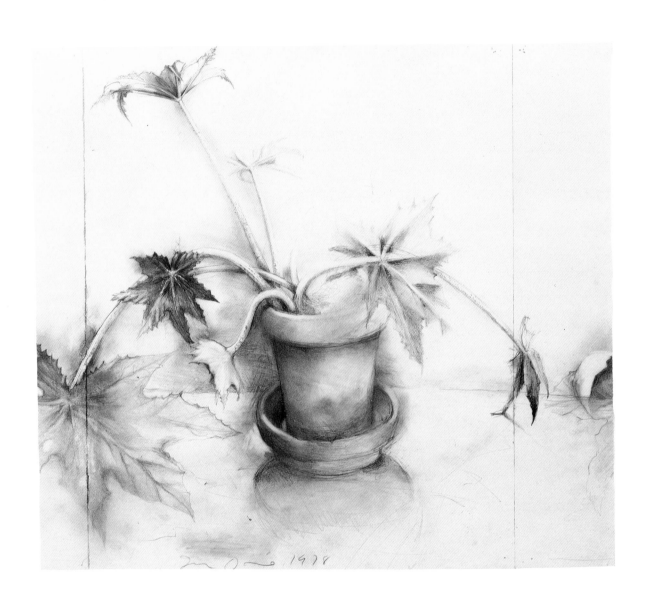

22. *Careful Pencil Drawing.* 1978. PENCIL ON
PAPER, 17½ × 19¾". COLLECTION NANCY DINE

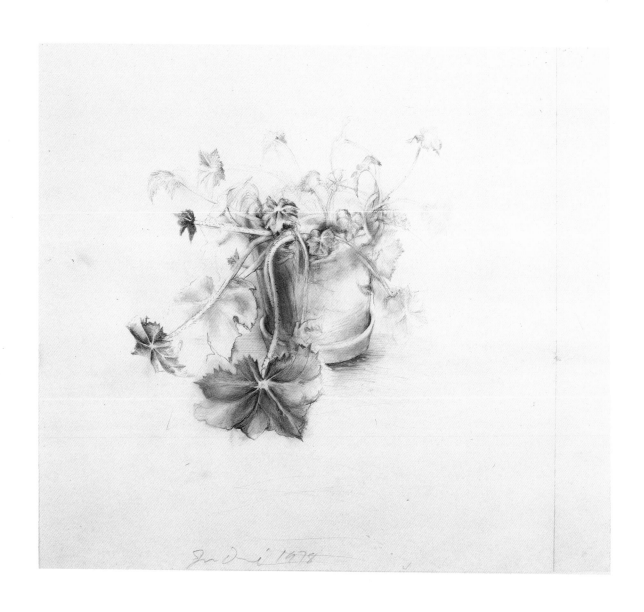

23. *Begonia, 83rd Street.* 1978. PENCIL ON PAPER,
17¼ × 19¾″. COLLECTION NANCY DINE

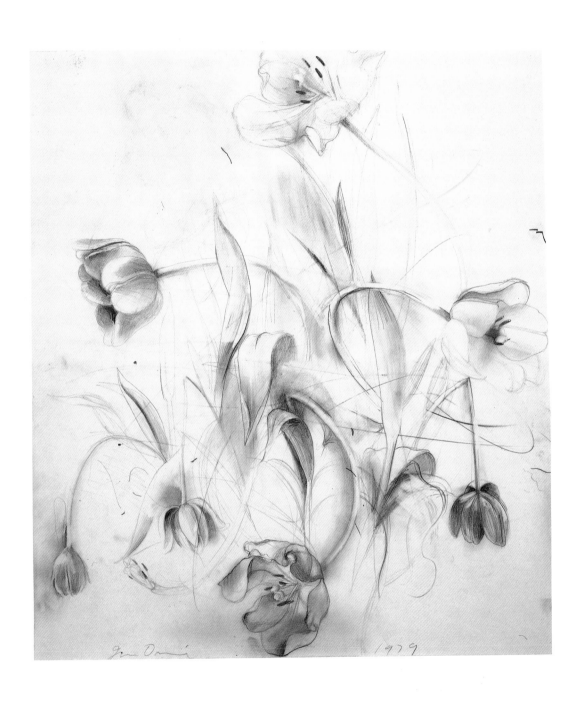

24. *Tulips.* 1979. PENCIL ON PAPER, 20 × 17½″.
PRIVATE COLLECTION, NEW YORK CITY

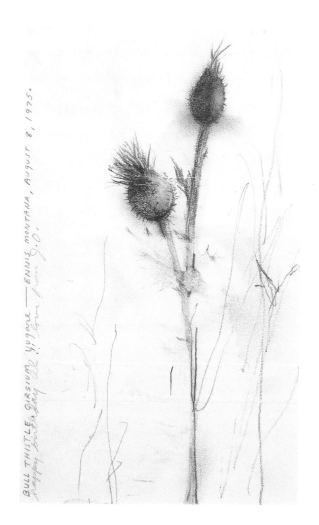

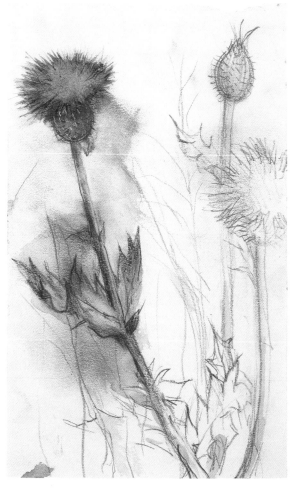

BULL THISTLE CIRSIUM VULGARE — ENNIS MONTANA, AUGUST 8, 1975.
Happy birthday dear 9! from 9.0.

25. *Bull Thistle.* 1975. PENCIL AND
WATERCOLOR ON PAPER, 9 × 11½".
COLLECTION ALFRED R. STERN

All opportunities for making claims to symbolic levels of meaning, through association with images of plants in earlier art, are subtly set aside by Dine. He explains, for instance, that he has no conscious intention of using cultivated flowers and plants as stylized symbols of organic growth and the life force, as they were used in Art Nouveau designs of the late nineteenth century; in fact, he plainly dislikes what he sees as the stylistic distortion of such art. It is to the meticulous illustrations of naturalists that he consistently returns for guidance, and not because he regards them simply as objective transcriptions of reality; if that was all he wanted from them, he could probably rely instead on color photographs. On the contrary, they appeal to him, like so much other art, for the way in which the plants have been rendered by hand, for the eloquence and gracefulness of their compositions, in short for their particular look as evidence of the draftsman's personality.

I'm ... moved by anonymous botanical illustrators through the ages, people who sat down in front of the plant and made an offering, that really gets to me. And you can find them everywhere. On the quais in Paris, in the bookstalls, in libraries, in secondhand bookshops.

At the Royal Horticultural Society shows, at these old booksellers, they'll have a couple of rows slipped in there somehow, and you'll see there's something [sketched] in the margin. It's killing. It's really a chilling thing when you come upon it, someone who's made this offering.

This spirit of reverence towards nature animated Dine's own move into botanical imagery. He readily concedes that one of his earliest such drawings from life, *Bull Thistle,* 1975 (fig. 25), owes much to the work of such illustrators as Linnaeus and Redouté in its scrupulous recording of linear detail and in its silhouetting of the plant against a plain white background. It was drawn during a visit one summer to a friend in Montana; moved by the wild flowers that he saw in the fields, Dine simply sat down and drew them. His recollection is that the more heavily worked sheet with the thistle in bloom came first, and that on completing it he decided to add another view of the buds alone.

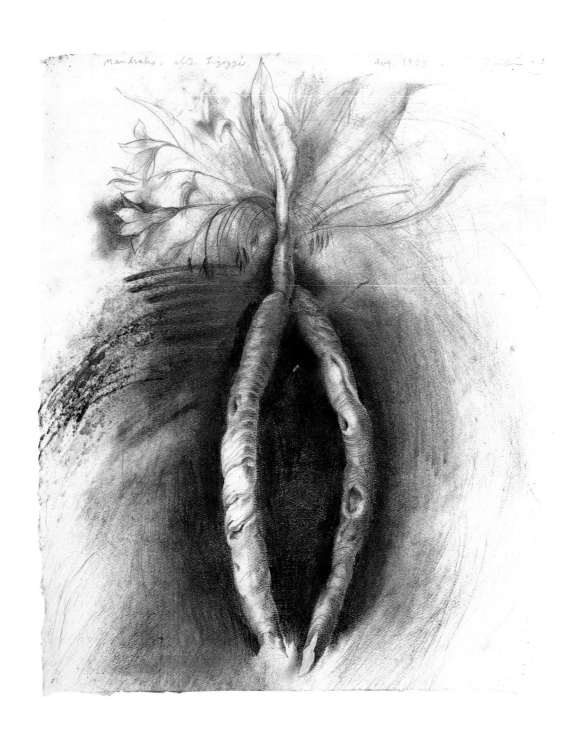

26. *Mandrake Root (After Ligozzi).* 1985. PENCIL, CHARCOAL, AND WATERCOLOR ON PAPER, 21½ × 17½″. COLLECTION THE ARTIST

Most of Dine's botanical drawings have been made from life, and for him there is a great difference between drawing from an image of a plant and drawing from the plant itself. "To work from another image is another thing, you're trying to make something come alive." When working from existing images, it is generally a question of convenience: "You don't have to worry about watering them. You don't have to worry about the light. They're always there. It's not as inspiring, though." Yet making a drawing from a botanical illustration, as Dine did, for instance, in *Mandrake Root* (fig. 26), provides him with an opportunity for testing one of his greatest skills: that of animating, or reanimating, the inanimate. Without seeing this side by side with a reproduction of the fifteenth-century watercolor by Jacopo

Ligozzi from which he drew (fig. 27), which he likens in style to the work of Ehret, one would be hard-pressed to guess that Dine's plant had been freely transcribed from a printed source. While preserving not only the basic shape of the root but also the exact location of the various striations and hollows that form its distinctive texture, he has freely reinvented its plumage of leaves and flowers; through the fastidious shading of the plant, moreover, and by its dramatic placement against a densely worked blackened background, he has summoned it forth as a physical mass in a palpable space.

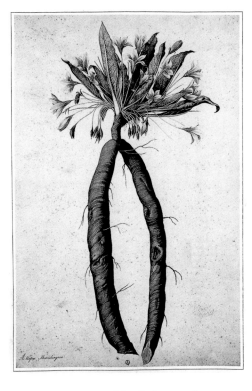

27. JACOPO LIGOZZI. *Mandrake.* C. 1480. WATERCOLOR ON PAPER. GALLERIA DEGLI UFFIZI, FLORENCE

31

The first of seven intoxicatingly luscious watercolors painted by Dine in 1984 (fig. 28) as studies for the book of twenty-nine drypoints and engravings published later that year as *The Temple of Flora,* in homage to Dr. Thornton's influential book of the same name, was modeled directly on the hand-colored image of tulips widely regarded as one of the most beautiful images from that volume (see fig. 14). While Dine has made no attempt to hide his source—following its general composition and color scheme, and even alluding to the romantically clouded sky of the original—he has rephrased it entirely in his own language. The moist atmosphere is not so much depicted as given material form in the successive washes of gray and blue, just as the blossoms are vigorously delineated in looping strokes that convey their voluptuous shapes and velvety texture. While remaining faithful to their local colors, Dine has intensified their hues, encouraging us to wallow in the sensory delirium of their imagined fragrance. In this and the subsequent watercolors in this group (figs. 29–34) he comes close to giving material form, in an utterly unself-conscious way, to the synaesthetic equivalents imagined by the French Symbolist poets: the evocation of one sense through another alluded to in poems such as "Voyelles" ("Vowels") by Arthur Rimbaud, and earlier still by Charles Baudelaire, who had written in his poem "Correspondances" of the relationships among smells, colors, and sounds.

28. *Study for The Temple of Flora No. 1.*
1984. WATERCOLOR AND PENCIL ON PAPER,
43 × 30½". COLLECTION THE ARTIST

29. *Study for The Temple of Flora No.* 2. 1984.
WATERCOLOR ON PAPER, 40 × 30″. COLLECTION
THE ARTIST

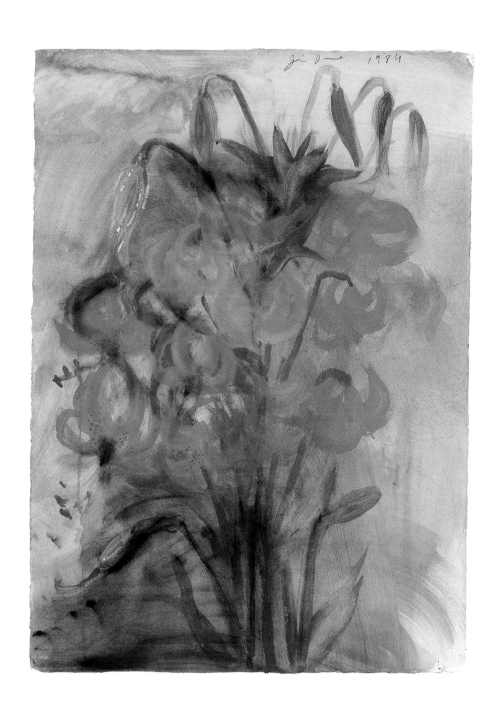

30. *Study for The Temple of Flora No. 3.* 1984.
WATERCOLOR ON PAPER, 30 × 22″. COLLECTION
THE ARTIST

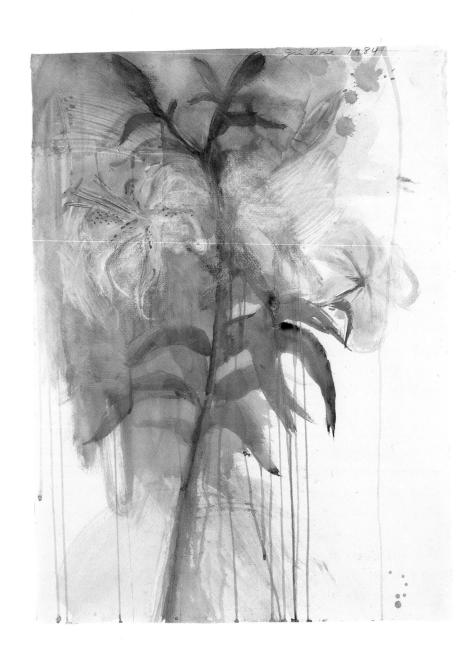

31. *Study for The Temple of Flora No. 4.*
1984. WATERCOLOR AND CHALK ON PAPER,
30½ × 23″. COLLECTION THE ARTIST

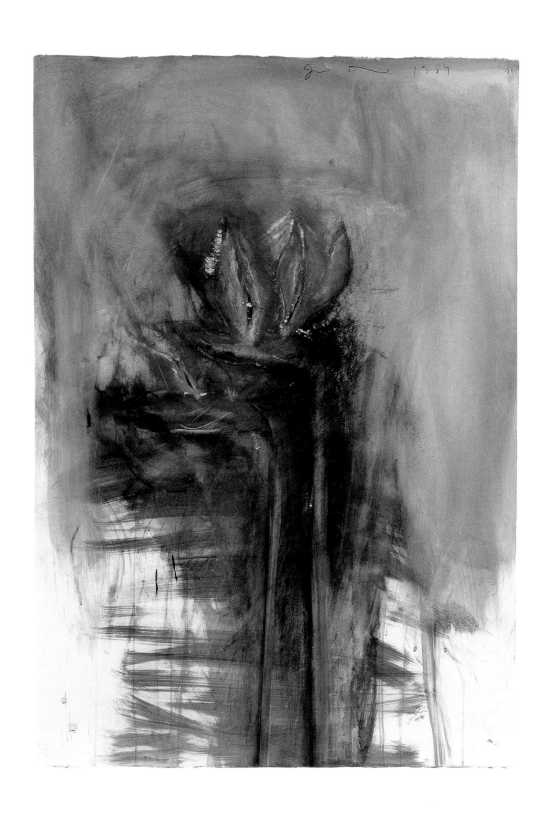

32. *Study for The Temple of Flora No. 5.* 1984.
WATERCOLOR, PASTEL, AND CHARCOAL ON
PAPER, 43 × 30½″. COLLECTION THE ARTIST

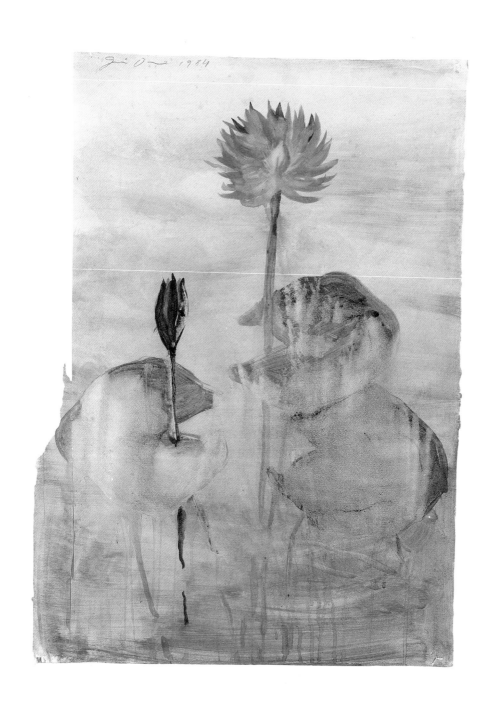

33. *Study for* The Temple of Flora *No. 6.* 1984.
WATERCOLOR ON PAPER, $31\frac{1}{2} \times 21\frac{3}{4}''$.
COLLECTION THE ARTIST

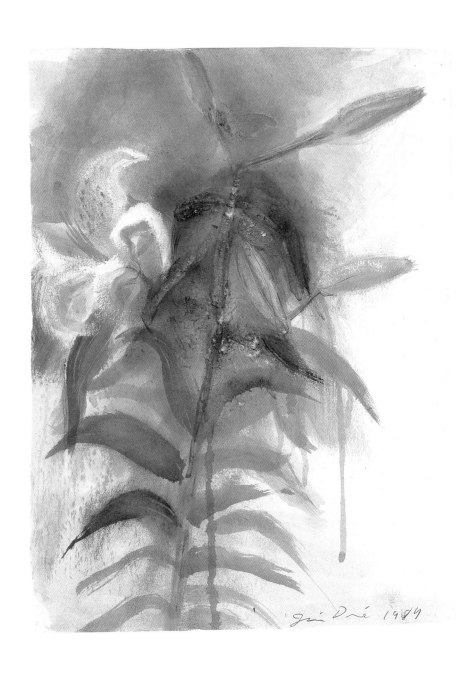

34. *Study for The Temple of Flora No. 7.* 1984.
WATERCOLOR ON PAPER, 24 × 18". COLLECTION
THE ARTIST

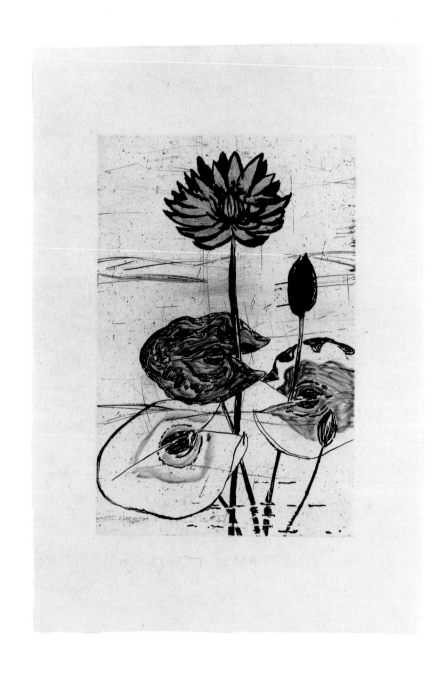

35. *Blue Egyptian Water Lily,* PLATE XIII FROM
The Temple of Flora. 1984. DRYPOINT, ENGRAVING,
AND ELECTRIC TOOLS, 18 × 12″

While Dine based twenty-four of the twenty-nine prints of his *Temple of Flora* directly on compositions published in Dr. Thornton's book, such correspondences are far less at issue in the preparatory watercolors, which are endowed with such a physical immediacy as to render inconsequential any speculations we might have about either their future or their past. It is perhaps for this reason, too, that only three of the watercolors were reformulated by Dine as prints: *No. 1*, redrawn in sparse outline as plate IV, with the uppermost flower missing; *No. 4* (fig. 31), representing a Superb Lily, reinterpreted as plate IX; and the Egyptian Water Lily painted with such delicacy in *No. 6* (fig. 33) given a new life in a print of exquisite linearity (fig. 35) recalling the turn-of-the-century art of Klimt and Schiele.

In their shimmering surfaces, naturalistic colors, and frankly decorative appeal, watercolors from this group, such as *Study for The Temple of Flora No. 5* (fig. 32), representing the exotic plant known as the Bird-of-Paradise, are among the most alluring of all Dine's botanical drawings. Confronted by the stems and leaves of the carnations shown in *Study for The Temple of Flora No. 2* (fig. 29), we are subject to a sensation similar to that engendered by Dürer's magical watercolor notation of a tuft of grass (fig. 36): a sense of having our nose, and our eyes, thrust right into nature itself.

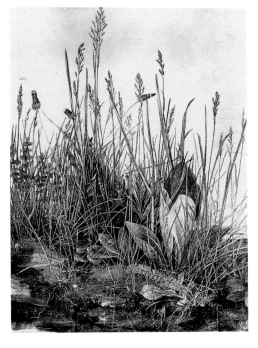

36. ALBRECHT DÜRER. *Great Tuft of Grass.* 1503. WATERCOLOR AND GOUACHE, 16⅛ × 12½". GRAPHISCHE SAMMLUNG, ALBERTINA, VIENNA

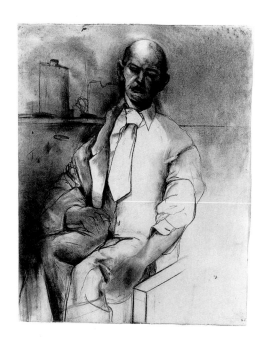

37. *The Die-Maker.* 1975. CHARCOAL, OIL, AND CRAYON ON PAPER, 40 × 30″. BRITISH MUSEUM, LONDON

The transformation effected by Dine in such works seems almost miraculous, but the means through which it has been achieved are laid plainly before us. The process has much in common with his revivifying of the human figure from dressmakers' dummies, as in certain drawings of the mid-1970s (fig. 37), or from classical statuary, as in the drawings made by him at the Glyptothek in Munich in the late 1980s (fig. 38). There is no attempt in the latter to conceal the fact that the figures are truncated and incomplete, their sculpted limbs or heads sometimes broken or lost

38. *Glyptothek Drawings, Drawing 6.* 1987–88. CHARCOAL AND CHALK ON MYLAR, 14¾ × 10¾″. THE PACE GALLERY

over the centuries, yet their volumes are so persuasively modeled and their outlines so freely and expressively drawn that we can still believe in them as renderings of living people. Like Pygmalion in Greek mythology, Dine appears to achieve the impossible: bringing sculpture to life. It is in such works, and in drawings based on botanical illustrations, that one can see most startlingly the deep affinity that Dine has with art from distant cultures; it is not a question of quoting from other art to demonstrate his knowledge, or of appropriating it as a shortcut to profundity of meaning, but of understanding the essentially unchanging nature of human experience and perception by imagining himself, through the artifacts of the past, in front of the motif.

On a few rare occasions, notably in a group of drawings made in 1983 after Van Gogh, Dine was able to make direct use of images by one of the modern artists who had served him as a mentor.[8] Two of these are of remarkably animated trees, which seem to be shaking in anger or simply out of a furious and uncontainable energy (fig. 39). Dine's reasons for being able to make such direct reference in this case were much the same as for his reliance on botanical engravings: "I felt those pollarded trees, I felt as though the tree was there from his drawings. His drawings

39. *Drawing from Van Gogh II.* 1983.
MIXED MEDIUMS ON PAPER, 77¾ × 48¾".
COLLECTION THE ARTIST

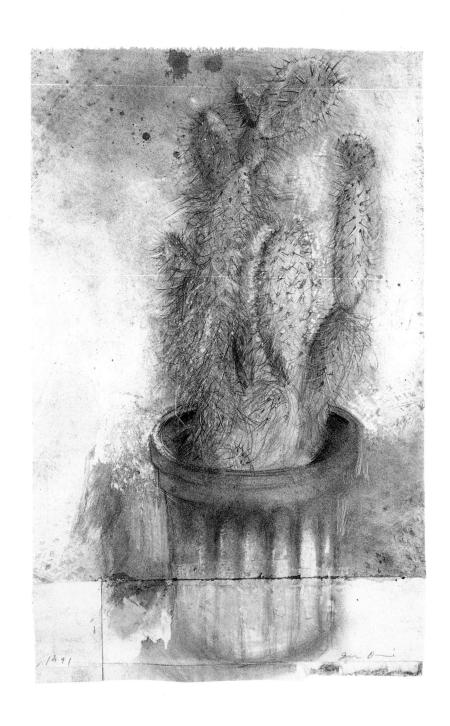

40. *Erect Cactus.* 1991. PENCIL, PASTEL,
AND COLORED PENCIL ON PAPER, 24 × 15″.
THE PACE GALLERY

seemed to come so hard for him, but so well observed, that I think he had done that work for me." Only very rarely, however, have associations with the work of other artists occurred to Dine while drawing from a plant, as in the case of his portrait of a cactus (fig. 40), which brought to mind the *Cactus Man* sculptures cast in bronze by Julio González in 1939 (fig. 41). It was not just that Dine's image of his model, like the Spaniard's invention, seems to be a hybrid of plant and human forms, half cactus and half man, but that he perceived the plant itself as a sculptural form.

Dine generally has drawn from plants that he has purchased specifically for this purpose, and he acknowledges a preference for succulents because of their sculptural quality. It is, in turn, this feeling for volume that has dictated the fundamentally monochromatic appearance of most of his botanical drawings, with the notable exception of his seven richly hued watercolor *Studies for The Temple of Flora* (figs. 28–34) in 1984 and of two uncharacteristically decorative watercolors, *Tulips* (fig. 42) and *Dark Red Dahlias* (fig. 43), in 1993. For the most part Dine has relied on pencil and charcoal as the most appropriate tools with which to establish the exact contours of the plants and also to describe their physical space by tonal means. Watercolor could not have served him as well for this purpose, and he rejected colored pencils because of a dislike of their chalky quality. It was not

out of perversity that he chose only rarely to use flowers, as other modern artists such as Matisse or Dufy had done, as an excuse for an almost abstract way of playing with color. His conspicuous avoidance of an ingratiating motif such as a bouquet of bright flowers was not the product, either, of a fear of breaking the modernist taboo against mere prettiness. As he explains,

I don't have to worry about mere prettiness, because my pictures are never like that, they're tougher than that. There's always a problem in them, they reflect the state of my mind and the way I see the world. And I've never thought about confronting the late twentieth-century avant-garde, either.... I've always done what I think is needed, for me, period. There is no other reason ... other than that I love the plants.

Dine's first concentrated group of botanical drawings in the mid- to late 1970s established a strange relationship, which evidently seemed to him entirely natural, between the volumetric treatment of the object and the ambiguous pictorial space in which it exists. As Dine himself observes, it is impossible to say where these things are except to assume that they are somehow simply "in nature." He admitted in an interview in 1979 that "I just like isolated things by themselves. I don't think a setting would corrupt, necessarily; it just isn't my interest to put a single object in an environment usually. Putting it in an environment makes it more illustrative and distracting, I think."[9] Now he remarks that he would not even think consciously about such matters, but that he would just act on his preference for a single image.

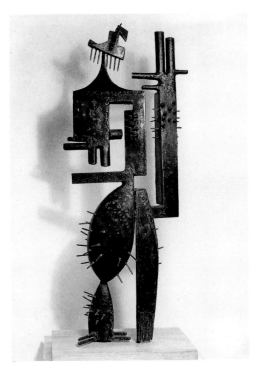

41. JULIO GONZÁLEZ. *Cactus Man I.* 1939. BRONZE, 25¾ × 10¾ × 6¼". MUSEU NACIONAL D'ART DE CATALUNYA, BARCELONA

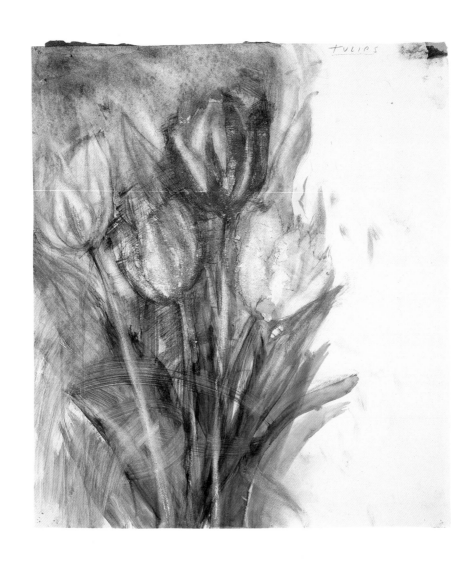

42. *Tulips.* 1993. WATERCOLOR AND CHARCOAL
ON PAPER, 21¼ × 19″. COLLECTION SUSAN DUNN

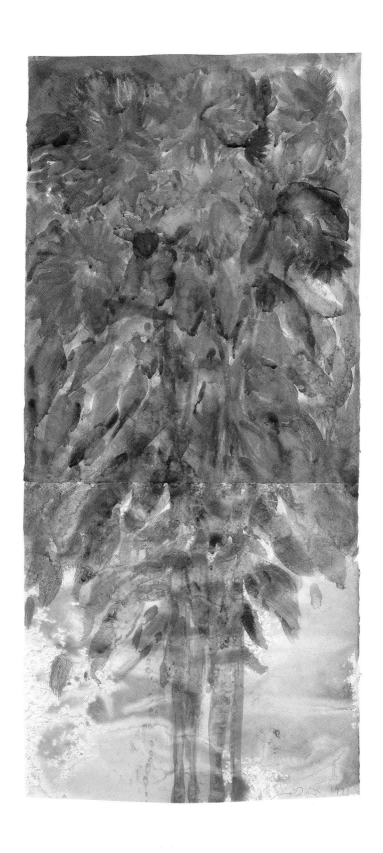

43. *Dark Red Dahlias.* 1993. WATERCOLOR
AND COLLAGE ON PAPER, 39¼ × 18¼".
COLLECTION VICTORIA DINE

In *Dried Liatris in a Bernard Leach Pot,* 1976 (fig. 44), both the minutely rendered plant and the gently curving vase in which it is contained display themselves as so physically present that we feel we might almost be able to grasp them in our hands, but everything around them is an undefinable atmosphere of light and space; we may presume that the vase rests on a tabletop, but there is no demarcation between this supposedly receding surface and a wall beyond. In fact, the surface with which our eyes come into contact, through this blackness, is that of the drawing itself. In subsequent works, such as *Lilies in New York No. 2,* 1980 (fig. 45), or the much later *Aurea's Save* (fig. 46) of 1992, and the *Tulips* (fig. 42) and *Jack-in-the-Pulpit* (fig. 47) of 1993, the whole atmosphere appears to tremble with life,

giving the plants an almost supernatural presence. "I see them in a kind of sea of protoplasm, part of the life force."

Just as Dine's drawings after the antique, including his numerous variations on the Venus de Milo, seem to have the lifeblood coursing through them, in spite of their anatomical incompleteness and their self-evidently historical sources, so in these studies from nature he has succeeded in suggesting that the whole of creation is present in every detail.

It's that same desire to depict natural energy and to make it one, not just to illustrate it but to make it one with your body, almost. And your body doing this work, to be at one with that. I often felt that making art, for me, for anybody, for those real artists in the world . . . is another way—I don't like to be corny about this—but it is another way of praying. Well, anyway, it's a way of saying thanks. And the recognition of natural energy and the power of natural energy is a very strong force in art, I think.

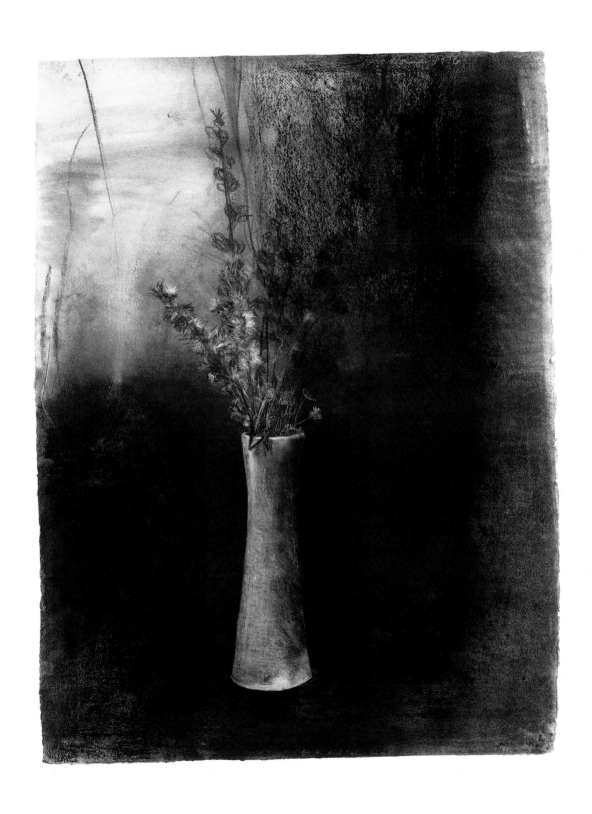

44. *Dried Liatris in a Bernard Leach Pot.* 1976.
CHARCOAL, PASTEL, AND CHALK ON PAPER,
39½ × 30″. COLLECTION NANCY DINE

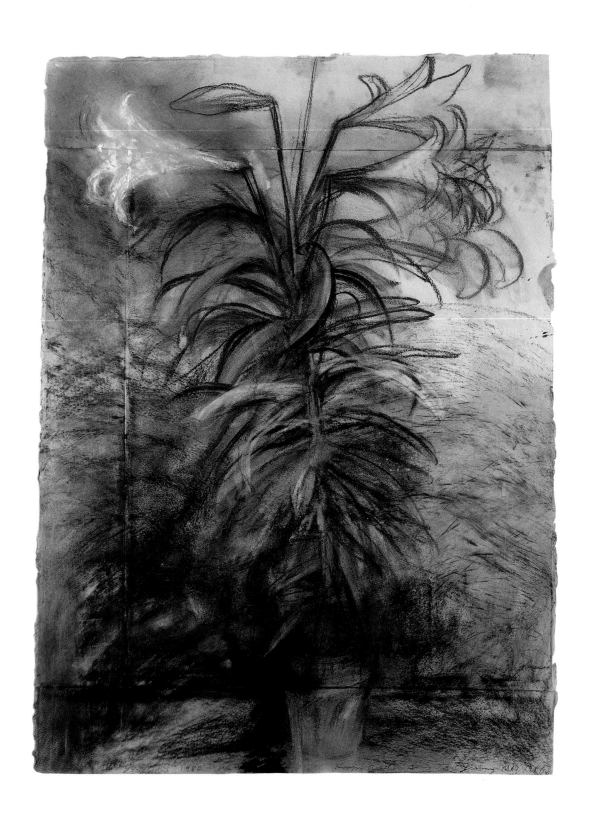

45. *Lilies in New York No. 2.* 1980. CHARCOAL,
PASTEL, INK, ACRYLIC, AND COLLAGE ON PAPER,
49½ × 37½″. COLLECTION ANNE ROBINOWITZ

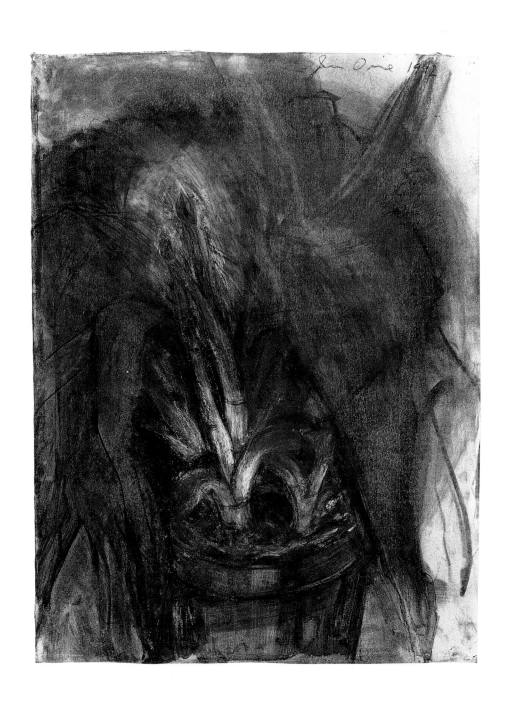

46. *Aurea's Save.* 1992. CHARCOAL, PENCIL,
PASTEL, AND CHALK ON PAPER, $18 \times 13\frac{1}{2}''$.
THE PACE GALLERY

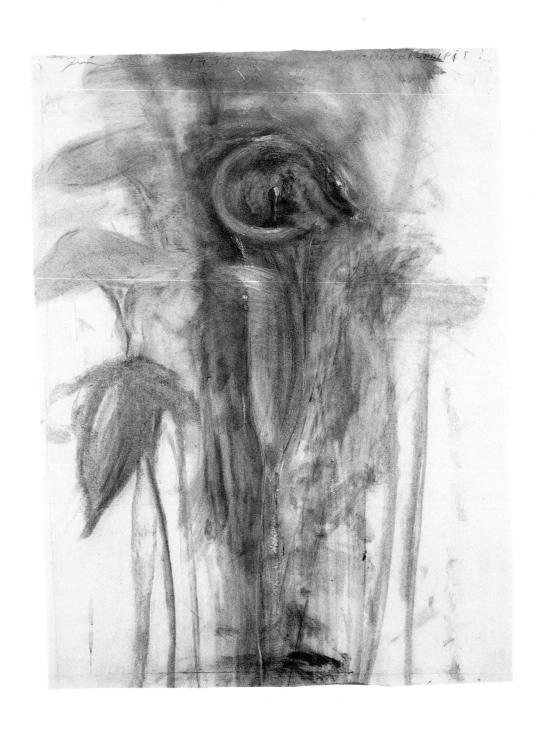

47. *Jack-in-the-Pulpit.* 1993. CHARCOAL,
WATERCOLOR, PENCIL, AND CHALK ON PAPER,
22½ × 17¼″. COLLECTION ANNE-MARIE
McINTYRE

The pair of potted-plant drawings executed by Dine in 1978 (figs. 22 and 23) are among the most naturalistic in treatment.

They were made at a time when I was drawing from the figure every day, too, so it was a way to observe something. I was sharpening my instrument, as it were, and I was far more interested in so-called figurative art than I am now. It was more important to me to be able to do that, then, because I hadn't done it yet to my satisfaction, probably.

Nevertheless, even these sober studies are not as self-effacing or objective as they might at first appear. In both there is an apparent distortion of scale in the treatment of a single leaf, particularly in the drawing in which it appears to be so huge that it cannot be contained by the edge of the sheet on which he was working.

Generally Dine's images of plants are on a one-to-one scale with the plants themselves, not out of any programmatic desire to be logical but only because this felt to him like the correct way to respond to the object. In this case, however, that one leaf is shown as noticeably larger than it must have been in reality. The size of this leaf in relation to the rest of the plant, therefore, defines the artist's changing position in the act of scrutinizing it. This evidence of his subjectivity goes hand in hand with the "incompleteness" of the drawing as a way of conveying his focused gaze, as distinct from the kind of indiscriminate panning across the surface that characterizes most images obtained through the lens of a camera.

These subtle manifestations of the artist's responses to the object he is drawing find a correspondence, too, in the physical layering by which the image is formed. The stem leading to the oversized leaf in the more extreme of the two drawings has been built up as a highlight with two thin strips of cream-colored paper, giving it a physical identity—barely visible in reproduction—equivalent to that of the form it represents. There are numerous instances of such procedures in the drawings made by Dine in later years. It is not so much a question of revealing the process for the sake of it, as of working at constructing the image intuitively, impulsively, at times even aggressively, until a physically persuasive form emerges. An extreme instance can be found in *Peonies, Summer 1991* (fig. 48)—a work notable, too, for its off-center placement of the image—in which the artist appears first to have attempted to correct the drawing of the glass vase's contours by scraping out the marks, and then to have ripped out this entire section of the sheet and repasted it roughly into position. His impatience here, bringing him close to destroying the drawing and certainly to tempering its otherwise gentle appeal with an unexpected violence, eventually

brought about the desired result: that of presenting the transparent container as an object in its own right.

Beginning in almost every instance with a single sheet, Dine often hinges onto this a second or even third sheet, so that the image develops as organically as the plant itself. Such is the case with two drawings that are otherwise very different in character from each other: *Common Mullein,* 1993 (fig. 49), with its spirelike form gracefully traced in pencil and charcoal, and the almost intemperately colorful *Dark Red Dahlias,* 1993 (fig. 43), the red blossoms and dense foliage of which appear to be erupting from the confines of the paper. No attempt is made to hide the joins; indeed, in a drawing such as *Easter Lily in New York,* 1980–82 (fig. 50), the obviousness of the addition gives the impression of having created a space into which the plant has been able to grow. The sensation, as in so many of Dine's pictures, is of an irrepressible, burgeoning life. Another drawing of that plant and on the same kind of paper, *Lilies in New York,* 1980 (fig. 51), probably worked on concurrently with this one, has additional strips along both the top and the right-hand sides. In this case the edges provide another kind of drawn line, in rectilinear counterpoint to the forms more freely rendered in charcoal, and a satisfyingly formal structure that contains even the wildest signs of activity within it, including the heel print of the artist's shoe.

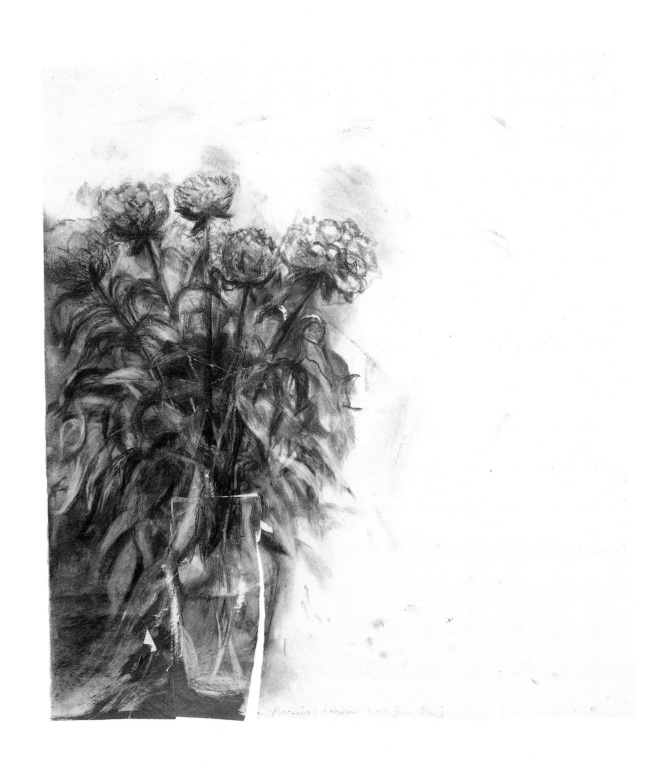

48. *Peonies, Summer 1991.* 1991. CHARCOAL,
PENCIL, COLORED PENCIL, WATERCOLOR, AND
OIL ON PAPER, 38 × 34¾″. PRIVATE
COLLECTION, NEW YORK CITY

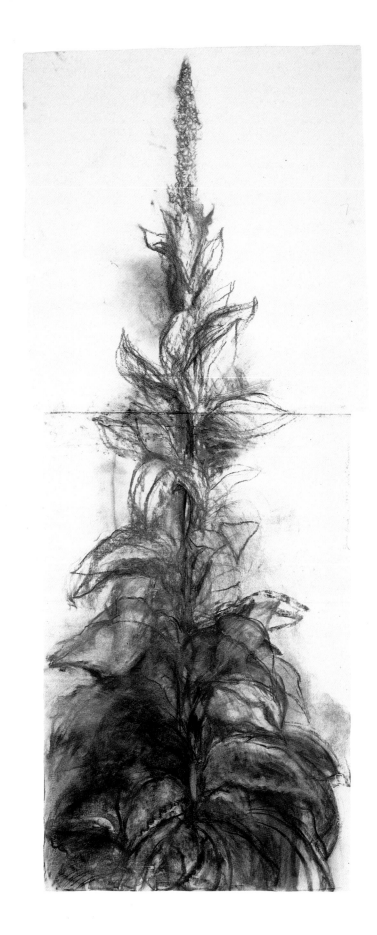

49. *Common Mullein.* 1993. CHARCOAL AND
PENCIL WITH COLLAGE ON PAPER, 72½ × 30½″.
COLLECTION THE ARTIST

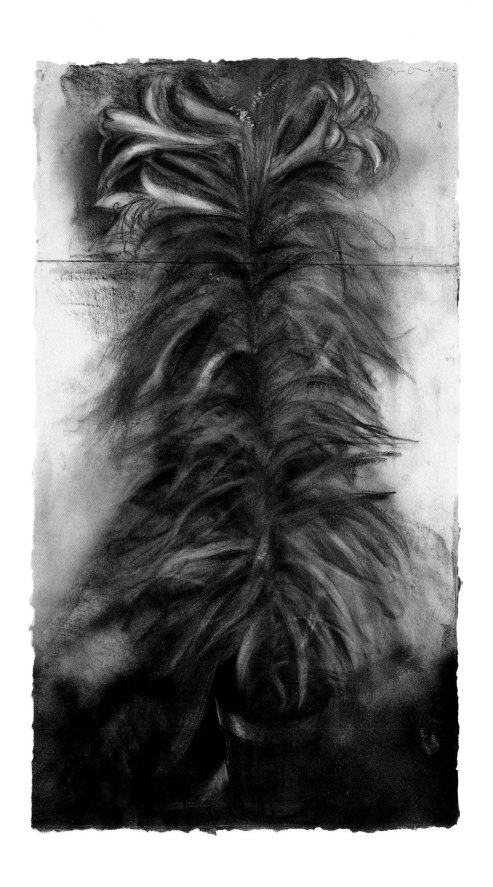

50. *Easter Lily in New York.* 1980–82. CHARCOAL
ON PAPER, 53 × 30¼". PRIVATE COLLECTION,
NEW YORK CITY

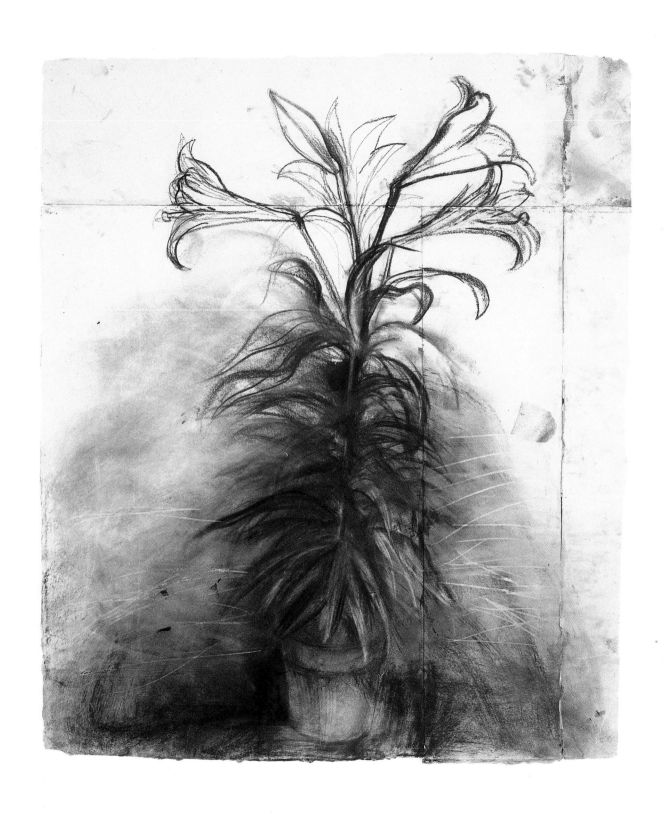

51. *Lilies in New York.* 1980. CHARCOAL AND
COLLAGE ON PAPER, 51½ × 44¾". COLLECTION
THE ARTIST

Begonia in Yemen Moishe, 1979 (fig. 52), was observed slowly every afternoon, "as a way to relax," during Dine's stay in Jerusalem in the summer of 1979. Yet this image, too, stops well short of a uniform finish, with one leaf barely sketched in. Even when Dine comes closest to the hard and brittle technique of academic traditions of life drawing, as in this and other densely worked drawings of the late 1970s, he feels free to "correct" or reinvent the image afterwards in order to make it seem more true. These tend also to be the drawings that have been worked on for longer periods. He began *The Jade Plant*, 1976–77 (fig. 53), for instance, in Vermont while lying in bed with the flu over the course of an entire week. A year later he removed it from the frame and reworked it, without having the plant to hand, because "It needed sharpening. It wasn't observed enough, and I had to scrape away a bit. It just made it come alive more."

The selectivity of the artist's vision is manifested with particular clarity in a pair of large charcoal drawings made in 1977, *Dried Liatris No. 1* and *Dried Liatris No. 2* (figs. 54 and 55). Both include a haze of pink pastel around the pot and buds, not as a descriptive local color specific to either of these elements but as a general atmosphere emanating from the natural and man-made forms alike. The basic arrangement of objects, including his beloved Bernard Leach pot, is essentially the same in both, but the elements are subtly shifted in position—as was true also of the objects featured in the large still-life paintings on which Dine was working in the same period (fig. 56)—and given a different emphasis. For instance, the tube of paint is assertively outlined in the first drawing but is almost invisible in the second; conversely, the hat is much more physically present in the latter than in the former. Cumulatively, these and other variations provide a vivid sense of the artist's restlessly shifting, and constantly refocusing, gaze.

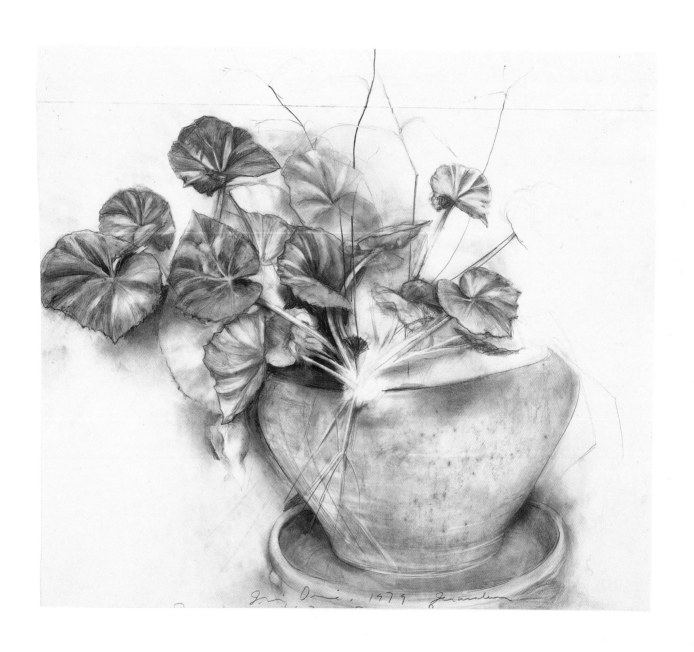

52. *Begonia in Yemen Moishe.* 1979. PENCIL ON
PAPER, 22½ × 25½″. PRIVATE COLLECTION,
NEW YORK CITY

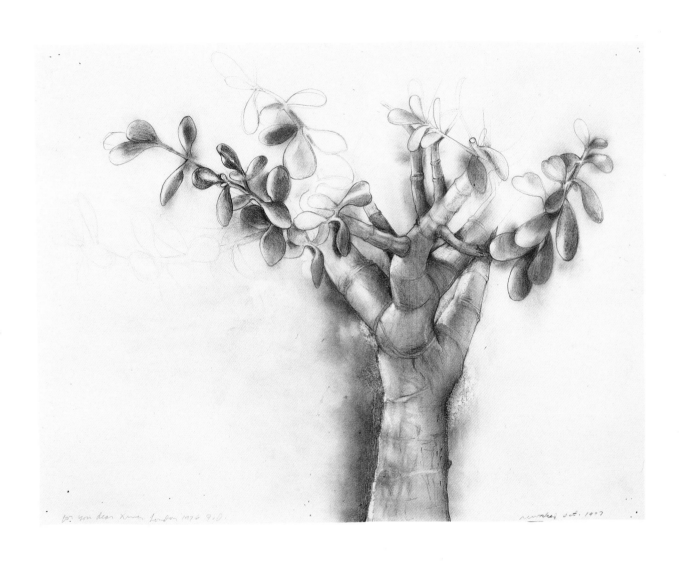

53. *The Jade Plant.* 1976–77. PENCIL ON PAPER,
15 × 19½". COLLECTION NANCY DINE

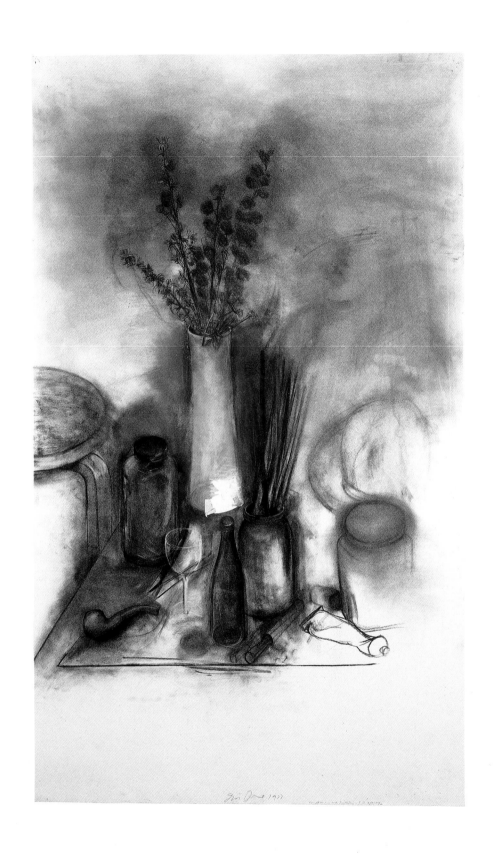

54. *Dried Liatris No. 1.* 1977. CHARCOAL
AND PASTEL ON PAPER, 60 × 36″. PRIVATE
COLLECTION, NEW YORK CITY

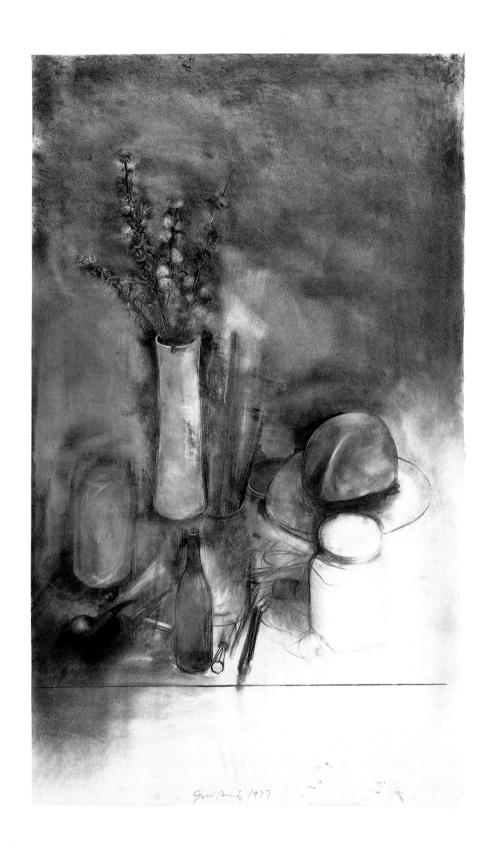

55. *Dried Liatris No. 2.* 1977. CHARCOAL
AND PASTEL ON PAPER, 60 × 36″. PRIVATE
COLLECTION, NEW YORK CITY

56. *The Still Life Painted on the Same Things and Then Varied and Then Married.* 1977. OIL ON CANVAS, FOUR PANELS, EACH 36 × 36″

Among the earliest botanical images by Dine were those drawn by him onto about a dozen ceramic pots in 1976 and 1977, with oxide pencils and oxide, and then clear glazed (figs. 57–58 and 61–67). The pots were made to his designs in London by a friend, Mary Day Lanier, the wife of the philosopher and writer on art Richard Wollheim. He sent her drawings of the shapes he wanted, indicating their approximate sizes, and specified in all but one case that their bodies be cream or off-white, giving the surface a tonal warmth similar to that of handmade papers and also making it sufficiently light for the drawn forms to register clearly against it. Although he denies that an association between pots and plants spurred him

towards this subject matter, the context of these drawings may have influenced him in his choice at least on an unconscious level, since botanical motifs were used on all the pots. In almost every instance the stems of the plants rise from the bottom edge of the pot, as if we were looking through transparent vessels at actual plants delicately arranged inside them; the superimposition of a clear glaze adds to this sense of looking through a surface that is at once reflective but almost invisible, an effect which the artist compares to that of examining a framed drawing through a layer of protective glass. (Years later, in *A Bowl of Lilies,* 1990 [fig. 59], Dine depicted a generous arrangement of flowers in just such a glass vessel, the water adding another transparent layer through which the stems are viewed.) Accidental effects brought about through the process were welcomed, as in the fine craquelure of the glaze in *Begonia in Brown and Black (Ceramic),* 1976 (fig. 57), which adds surface interest and becomes part of the texture of the drawing.

57. *Begonia in Brown and Black (Ceramic).* 1976.
(TWO VIEWS). OXIDE PENCIL AND CLEAR
GLAZE ON CERAMIC, H. 12″, D. 12½″. POTTER:
MARY DAY LANIER. PRIVATE COLLECTION,
NEW YORK CITY

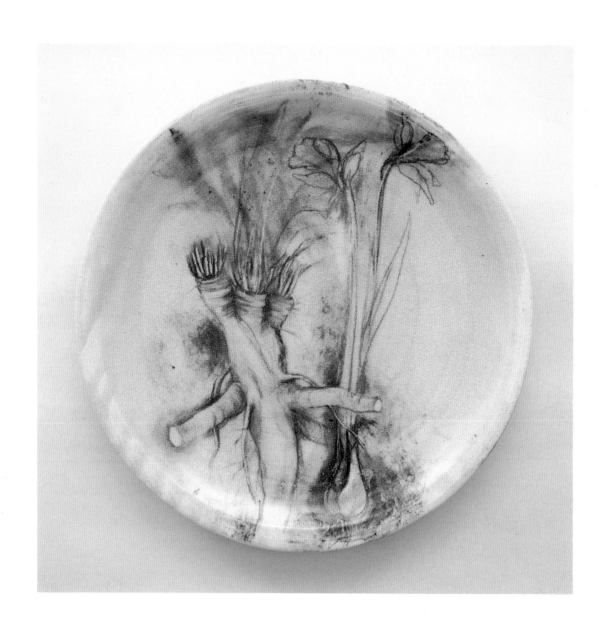

58. *Narcissus (Ceramic)*. 1977. OXIDE PENCIL
AND CLEAR GLAZE ON STONEWARE, H. 16½″,
D. 2½″. POTTER: MARY DAY LANIER. PRIVATE
COLLECTION, NEW YORK CITY

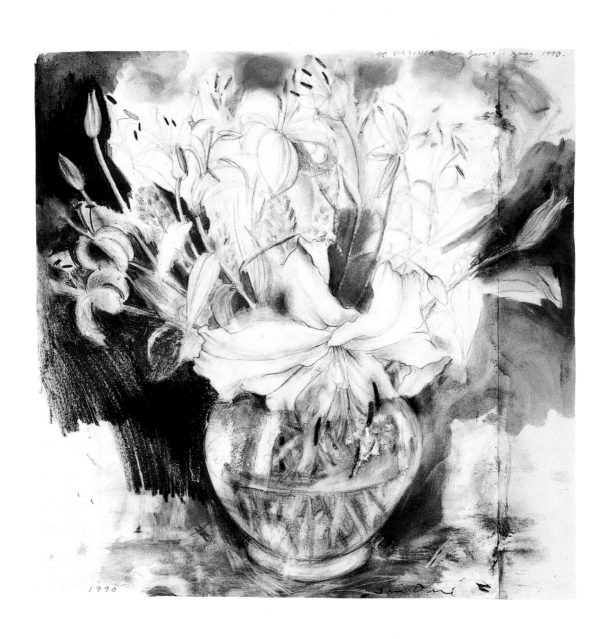

59. *A Bowl of Lilies.* 1990. PENCIL,
WATERCOLOR, AND COLORED PENCIL ON PAPER,
$18 \times 18\frac{1}{2}''$. PRIVATE COLLECTION,
NEW YORK CITY

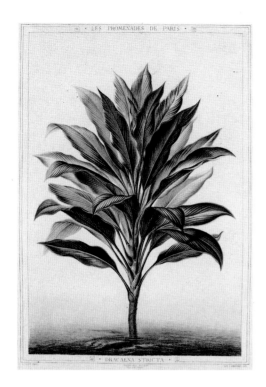

60. L. STROOBANT, AFTER A. FAGUET.
Dracaena Stricta. 19TH CENTURY. LITHOGRAPH,
16¼ × 11¼"

Working in the potter's garden in West London, Dine drew some of the motifs directly from life, as with the pollarded tree on *Narcissus (Ceramic),* 1977 (fig. 58). More generally, however, the motifs on his untitled ceramics were based on images from old botanical prints, as with his reinventions of a Dracaena Stricta from a nineteenth-century lithograph (fig. 60) on the front and back of the one piece made from red clay (fig. 61). The handling varies considerably from one work to another, the motifs sometimes boldly painted on in a rhythmic and decorative form, as in *Iris (Ceramic),* 1976 (fig. 62), or arranged as vibrant and translucent brushmarks in rich colors, as in *Crocus (Ceramic),* 1977 (fig. 63). Even those worked on with pencils vary from a sharp linear rendering, for example in the delicately traced forms of *Begonia in Brown and Black (Ceramic),* to the densely modeled technique used on pieces such as *Foxglove (Ceramic),* 1976 (fig. 64). In their impressive range they set the terms for many of the drawings on paper that followed, lending support to the artist's observation that they were not just decorations on the pots but fully formed drawings in their own right.

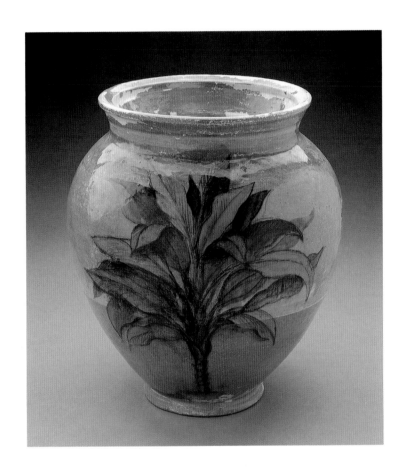
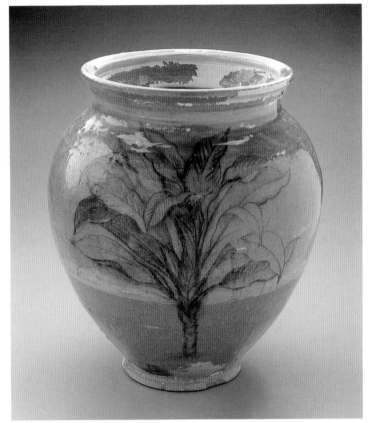

61. *Dracaena Stricta (Ceramic).* 1977.
(TWO VIEWS). OXIDE PENCIL, OXIDE AND CLEAR
GLAZE ON CERAMIC, H. 19″, D. 17½″. POTTER:
MARY DAY LANIER. COLLECTION THE ARTIST

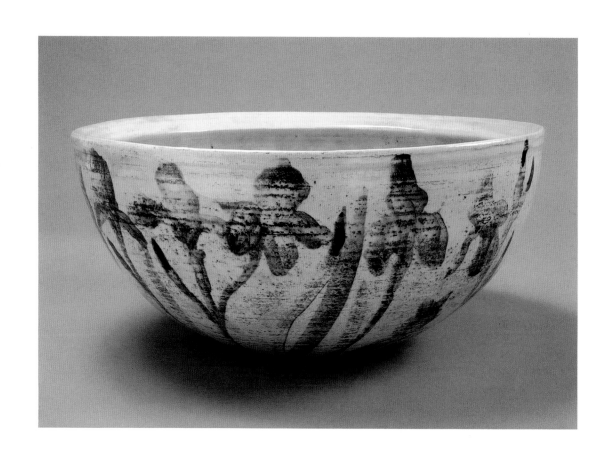

62. *Iris (Ceramic).* 1976. OXIDE AND CLEAR
GLAZE ON CERAMIC, H. 8″, D. 17″.
POTTER: MARY DAY LANIER. COLLECTION
ARNE AND MILLY GLIMCHER

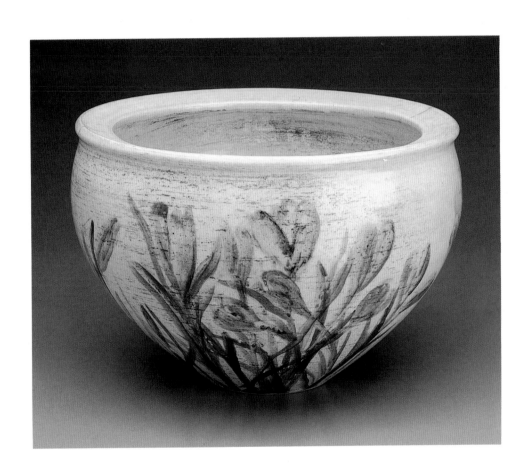

63. *Crocus (Ceramic)*. 1977. OXIDE AND CLEAR
GLAZE ON CERAMIC, H. 9½″, D. 14½″. POTTER:
MARY DAY LANIER. COLLECTION THE ARTIST

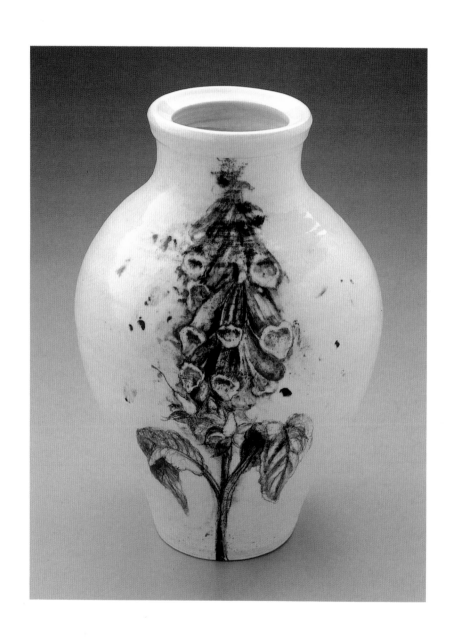

64. *Foxglove (Ceramic).* 1976. OXIDE PENCIL
AND CLEAR GLAZE ON CERAMIC, H. 17″,
D. 11½″. POTTER: MARY DAY LANIER.
COLLECTION THE ARTIST

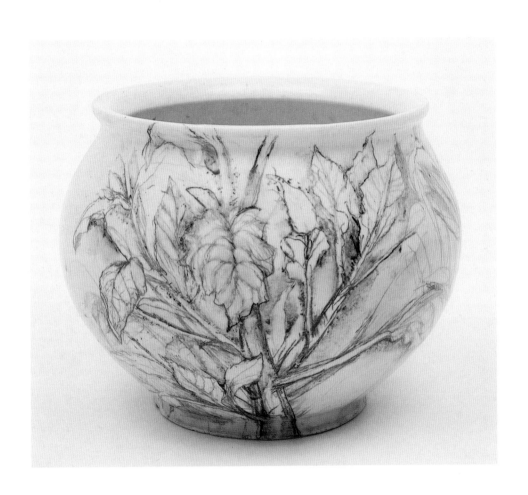

65. *Matt's Pot (Ceramic)*. 1976. OXIDE PENCIL
AND CLEAR GLAZE ON CERAMIC, H. 9″, D. 12″.
POTTER: MARY DAY LANIER. PRIVATE
COLLECTION, CRESTWOOD, NEW YORK

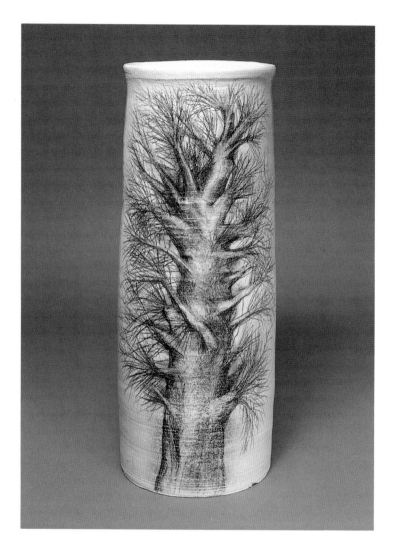

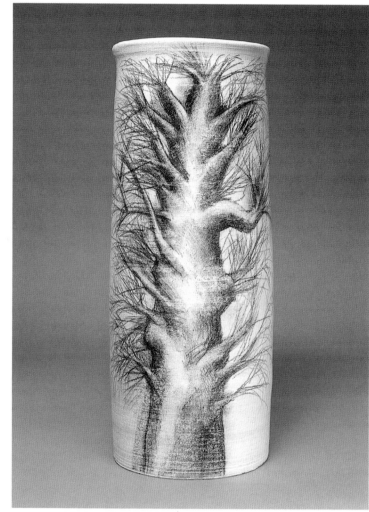

66. *Gene's Tree (Ceramic)*. 1976. (TWO VIEWS).
OXIDE PENCIL AND CLEAR GLAZE ON CERAMIC,
H. 26″, D. 11″. POTTER: MARY DAY LANIER.
COLLECTION GENE SUMMERS

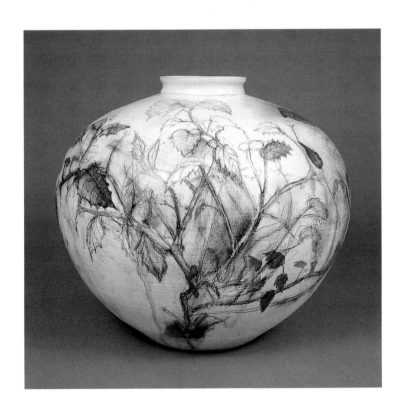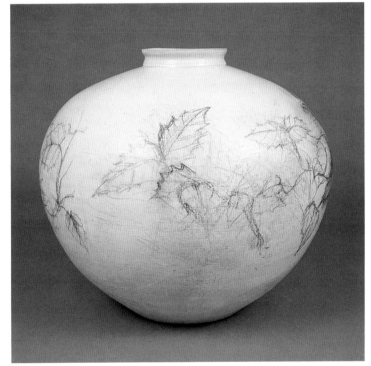

67. *Grape Ivy (Ceramic).* 1976. (TWO VIEWS).
OXIDE PENCIL, OXIDE AND CLEAR GLAZE ON
CERAMIC, H. 17″, D. 16″. POTTER: MARY DAY
LANIER. COLLECTION GENE SUMMERS

The relationship between Dine's plant drawings and existing motifs in printed form, as elaborated by him in the works on paper that followed these ceramics, is not limited to his use of eighteenth- and nineteenth-century botanical illustrations as reference material. Rather than working *from* the prints of other artists, in a number of instances he has produced unique variations on his own prints by drawing directly *over* one of his proofs, freely reinventing the forms as he goes. One of the earliest, and perhaps the most modest, of these interventions is *Blue Vase,* 1978 (fig. 68), in which he made some slight retouchings but otherwise reworked only one small area—that of the vase itself—of an impression of his etching *Red Ochre Flowers,* 1978. By applying blue watercolor to the shape of the vase, like a kind of glaze, and then scraping off part of this surface to form a highlight expressive of its swelling shape, he has subtly transformed the focus of the image from the flowers to the vase through recourse to a technique common in botanical illustrations: that of the hand-colored print.

Around five years later, in *Two Peacock Plants,* c. 1983 (fig. 69), Dine effected a much more complex transformation of a lithographically printed image, which itself reinterpreted two out of a series of three drawings of a Dracaena that he had made from life in 1980 with the intention of giving them to his sons as they turned twenty-one: *Jerusalem Plant (for Nick)* (fig. 70), the outlines of which can be discerned in the left-hand panel of the later drawing; *Jerusalem Plant (for Matt)* (fig. 71), its shape visibly present in the right-hand section; and *Jerusalem Plant (for Jeremy)* (fig. 72). The original drawings were all done while he was staying in Jerusalem to make some prints; he purchased a plant and drew it constantly in his room with charcoal, repeatedly rubbing out and reforming the image. An offset lithographic poster reproduction made in 1981 of the drawing dedicated to Nick led to eight editioned prints between 1982 and 1984, in the form of lithographs and woodcuts, in which Dine subjected the initial images to permutations that left intact the images that served as the point of departure while incorporating countless changes through a process of redrawing and reworking.[10] The double-image drawing relates to several of these, while differing from all of them, suggesting that it functioned less as a corrected trial proof than as a loose variation. With its rich contrast between the tonal grays of the printed forms and the bold and impetuous outlines in black ink, it demonstrates Dine's ingenuity in giving birth to one image through another, and at the same time provides the picture with its particular character, through the layered quality of the marks.

68. *Blue Vase.* 1978. ETCHING WITH
WATERCOLOR ON PAPER, 30 × 22″

69. *Two Peacock Plants.* C. 1983. CHARCOAL,
CHALK, AND INK ON PAPER OVER LITHOGRAPH,
47½ × 56½". COLLECTION THE ARTIST

70. *Jerusalem Plant (for Nick).* 1980. CHARCOAL
AND COLLAGE ON PAPER, 40¼ × 32¼".
COLLECTION NICHOLAS DINE

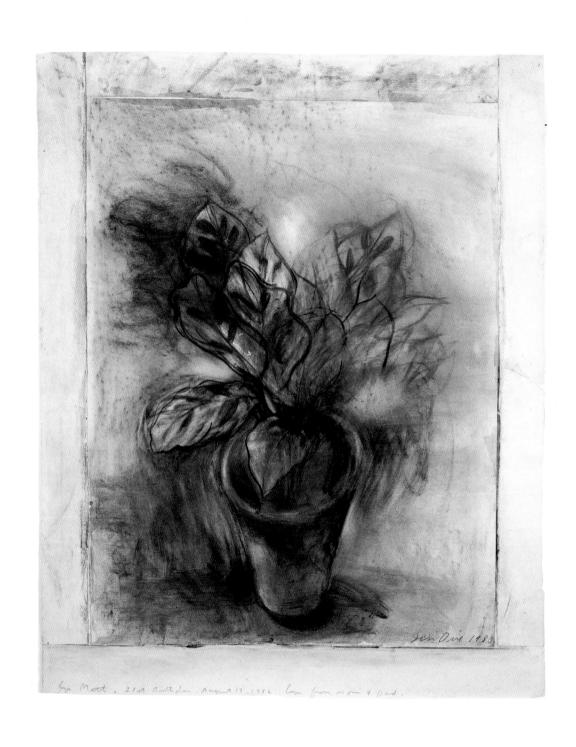

71. *Jerusalem Plant (for Matt).* 1980. CHARCOAL
AND COLLAGE ON PAPER, 41½ × 33".
COLLECTION MATT DINE

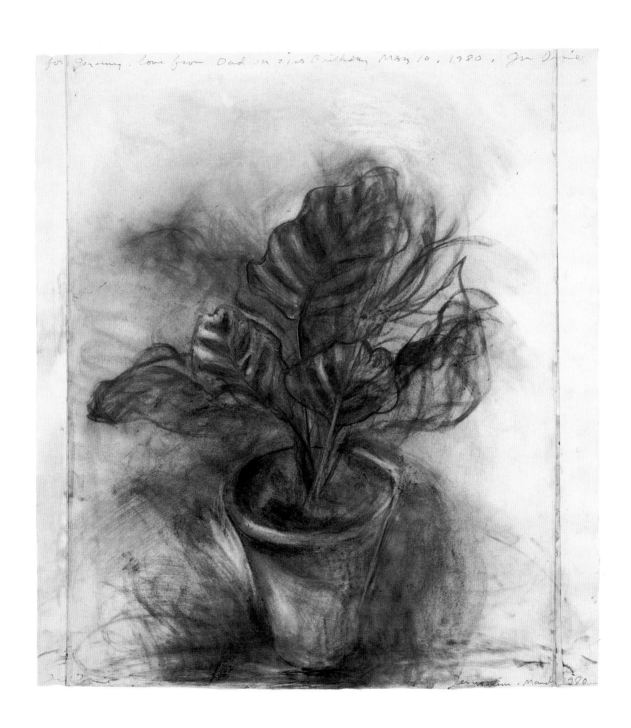

72. *Jerusalem Plant (for Jeremy)*. 1980. CHARCOAL
AND COLLAGE ON PAPER, 35½ × 32½″.
COLLECTION JEREMIAH DINE

The three drawings made by Dine in 1980 with the title *Strelitzia* (figs. 73–75), a further instance of the artist's continued reliance on the serial formats favored by him and other artists associated with Pop Art in the 1960s, also relate closely to a group of etchings of the same subject executed in the same year.[11] The six prints themselves were all variations made by printing at least twice from the same plate, with a certain amount of reworking and additions by other means, including monoprinting and hand painting. In this case the drawings and the prints could be regarded together as a single series, so closely does each group partake of the qualities of the other. Even the relationship in *Strelitzia No. 3* between the surrounding border and the compressed image of the plant within the rectangle is reflected in the format of one of the prints, *White Strelitzia*. The drawings, however, with their hinged-together sheets, are all considerably larger than the associated etchings, suggesting that in this case it was the drawings that came first; the reversal that appears to have been effected in the prints of the main outlines of the plant as seen in *Strelitzia No. 2*, furthermore, provides evidence that this drawing, in particular, may have been used as a guide in adapting the image to the copperplate.

There are no hard-and-fast rules in Dine's work: his paintings, drawings, prints, and sculptures have all fed off and into each other in different ways, with the attributes of one medium often so thoroughly transferred into another as to blur the distinctions between them. The *Strelitzia* series referred to here is among a large number of prints in which he enriched the surface by hand painting, effectively making each impression unique and giving it the physical density and richness of hue of his paintings. There is a strong painterliness to this group of drawings, too, achieved through the heavily worked layers of charcoal, pastel, oil, and spray paint.

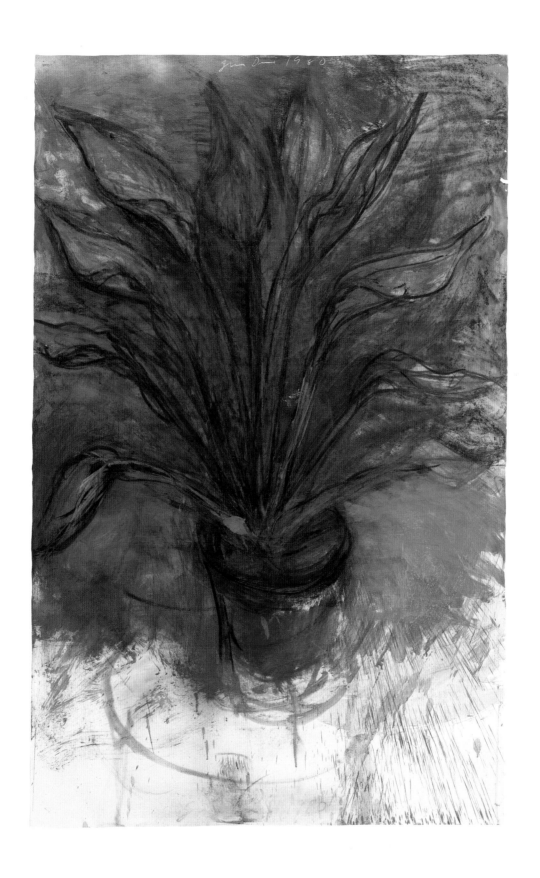

73. *Strelitzia No. 1.* 1980. CHARCOAL, PASTEL,
OIL, AND SPRAY PAINT ON PAPER, 56 × 36″.
PRIVATE COLLECTION, NEW YORK CITY

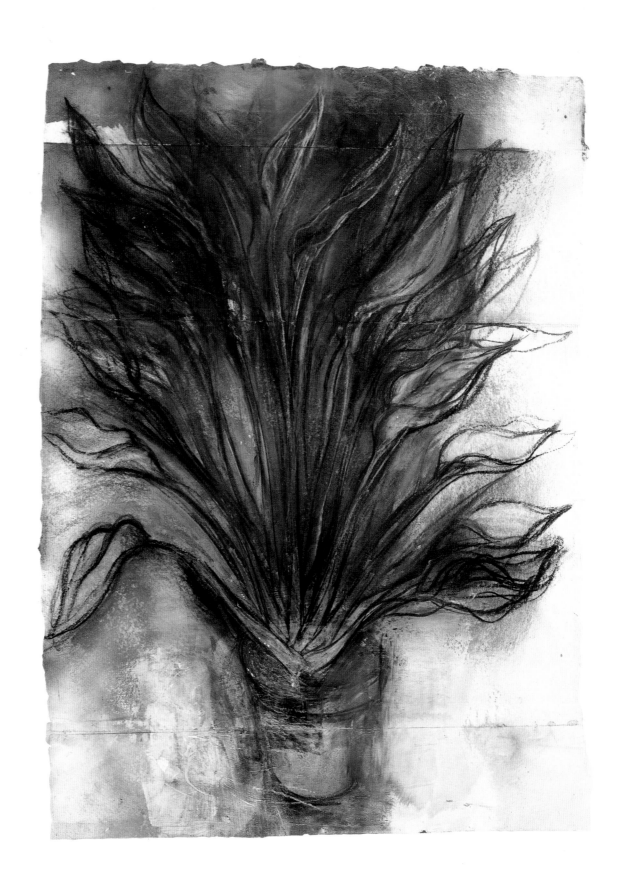

74. *Strelitzia No. 2.* 1980. CHARCOAL, PASTEL, AND SPRAY PAINT ON PAPER, 55 × 40″. PRIVATE COLLECTION, NEW YORK CITY

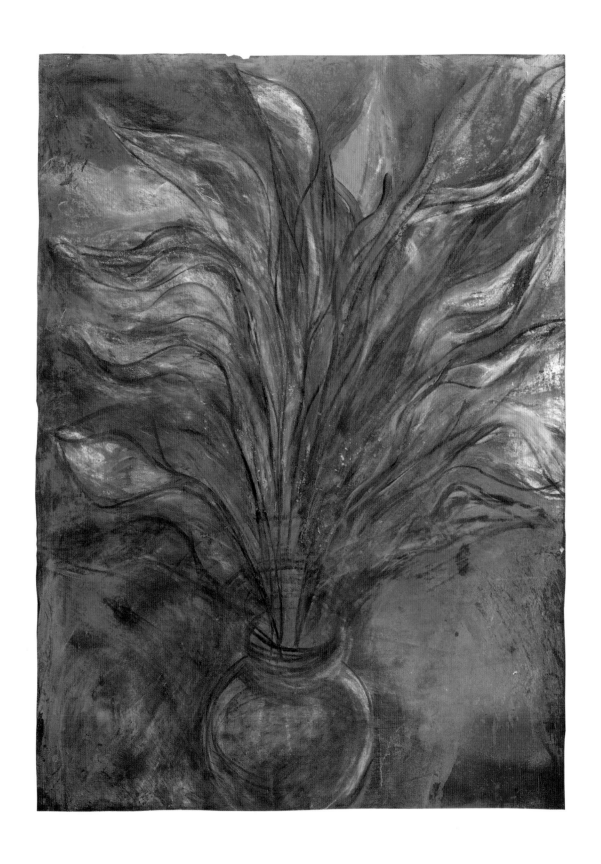

75. *Strelitzia No. 3.* 1980. CHARCOAL AND
PASTEL ON PAPER, 54 × 42½". PRIVATE
COLLECTION, NEW YORK CITY

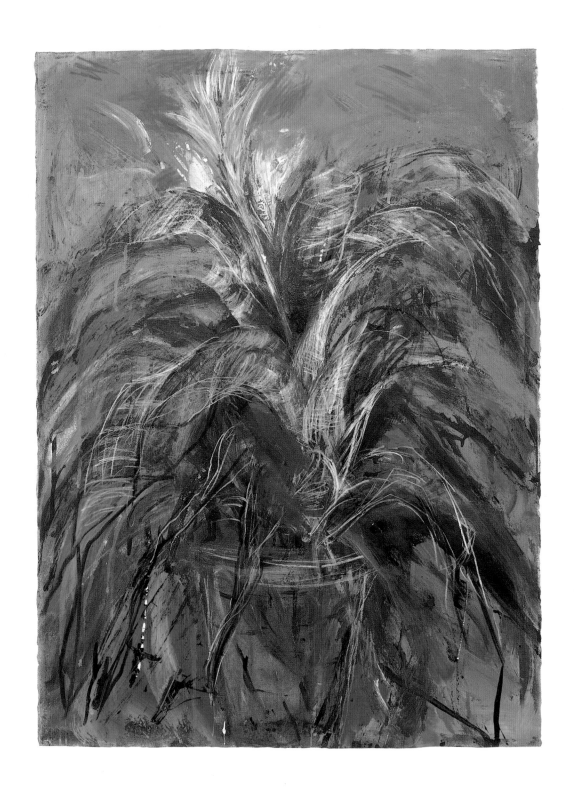

76. *A Bromeliad.* 1991. CHARCOAL, COLORED
PENCIL, PENCIL, WATERCOLOR, GOUACHE,
ENAMEL, AND OIL ON PAPER, 30 × 22½″.
THE PACE GALLERY

With the glorious exception of the seven sumptuously decorative *Studies for The Temple of Flora* in 1984 (figs. 28–34), another eleven years were to pass before Dine again made a group of plant drawings of such coloristic intensity and painterly richness. Notable among these works, most of them executed during a short stay in London in November 1991, are *A Bromeliad* (fig. 76) and several variations on an Anthurium (figs. 77–83). Drawing and painting in the dimness of the available light of his studio, or with just a small amount of electric light to allow him to see what he was doing, he constantly moved the plant around so as to obtain different views of its leaves and flowers. The results are far less subservient to the motif than had been the case with his botanical drawings of the mid-1970s, and the degree of subjectivity that had been inherent to them from the beginning is now allowed to run riot. The dark backgrounds convey the circumstances in which he was working, with the layering of one image of the plant over another giving them a sense of profuse, jungle-like growth, which he describes as "an atmosphere of living tropicality."

In such drawings Dine indulges the expressionist tendencies that have always guided him, without, however, abandoning direct observation. For example, in another drawing from this series, *White Lines* (fig. 80), white enamel paint is dripped and flung on the surface, in a manner recalling both Pollock and de Kooning, to heighten the sense of the plant's organic growth. Part of the thrill lies in the possibility of building up the surface to such a density that the very freshness of the marks might be destroyed. "I love that situation when you're really in the mud, and you've gone too far and you've got to bring it back somehow. That's what happened in *White Lines*. I think even the pencil that I was using is glued to the thing; it just dropped onto the paint and I left it." A similar process was enacted in a drawing that he describes as "very loosely observed," *Anthurium, Night and Day* (fig. 79): "It probably was carefully observed at first, and then I went in with black enamel and kind of destroyed all that. I used this stringy white paint again . . . and I also glued down the piece of charcoal I was using to get a straight black line right down there at the bottom."

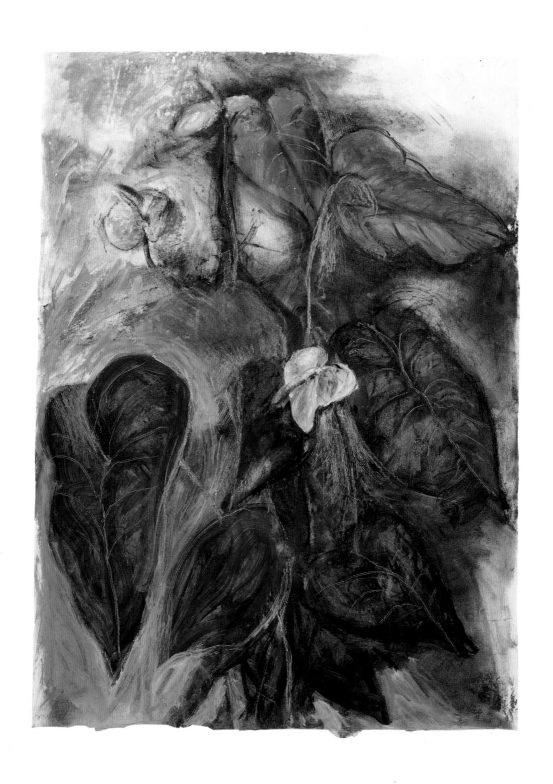

77. *Anthurium No. 1.* 1991. WATERCOLOR,
CHARCOAL, AND OIL ON PAPER, 36 × 27″.
PRIVATE COLLECTION, NEW YORK CITY

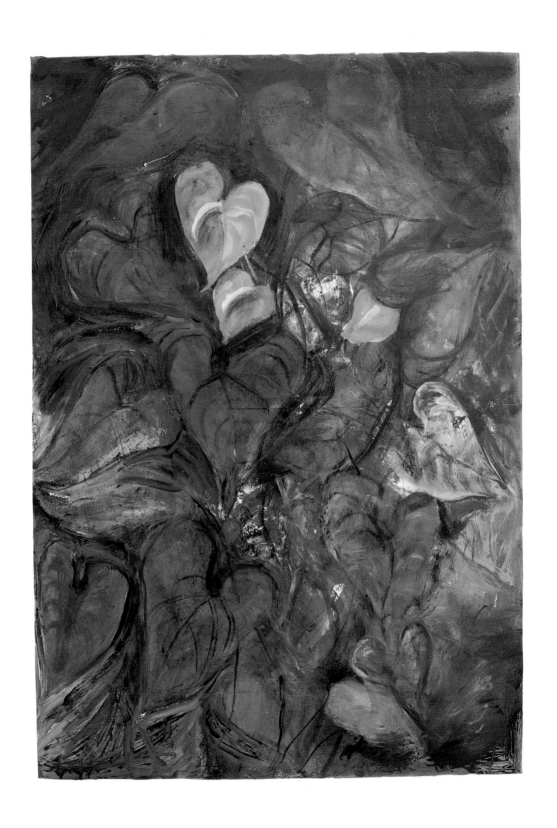

78. *Anthurium at Night.* 1991. CHARCOAL,
ENAMEL, OIL, AND ACRYLIC ON PAPER, 43 × 30″.
THE PACE GALLERY

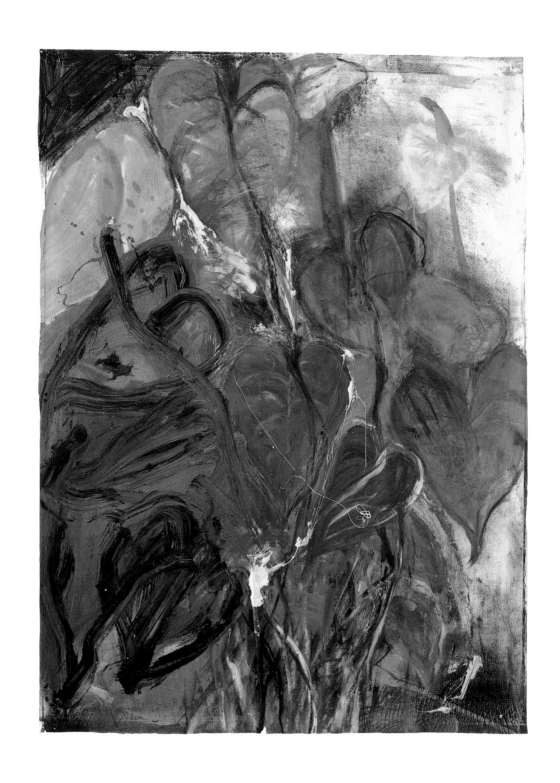

79. *Anthurium, Night and Day.* 1991.
CHARCOAL, ENAMEL, OIL PASTEL, AND
WATERCOLOR OVER ETCHING ON PAPER,
31½ × 23½″. COLLECTION THE ARTIST

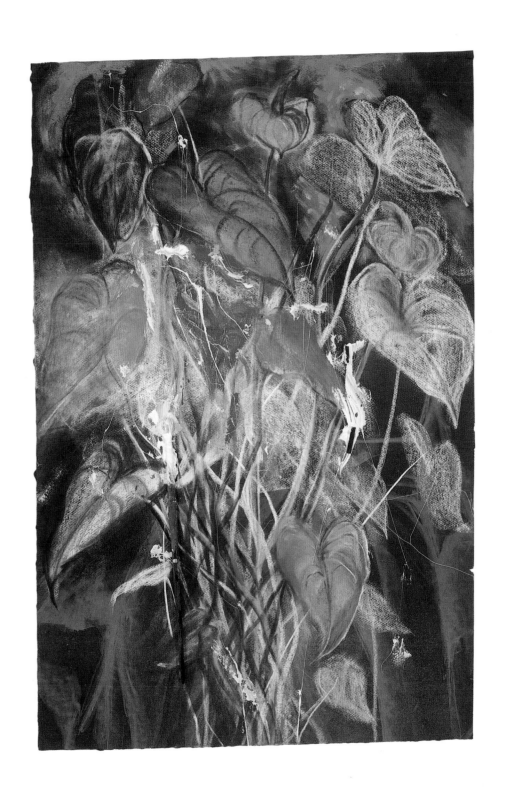

80. *White Lines.* 1991. ENAMEL, PASTEL,
CHARCOAL, AND COLLAGE ON BLACK PAPER,
35½ × 23½″. PRIVATE COLLECTION,
SWITZERLAND

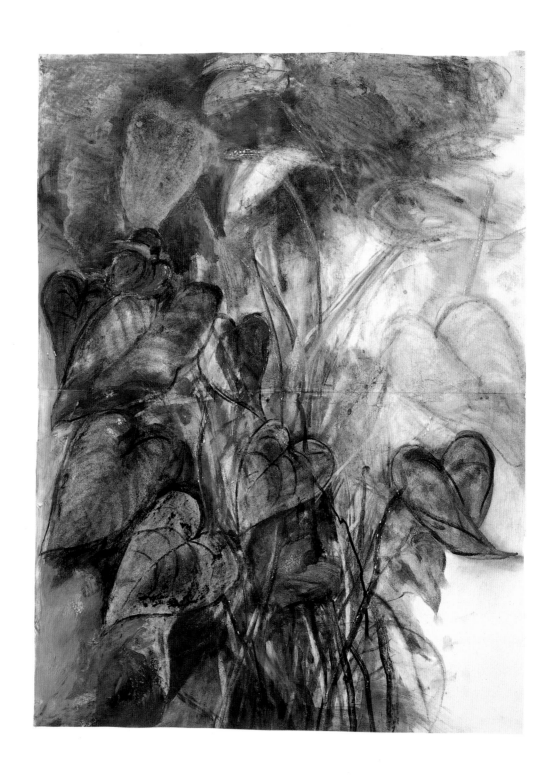

81. *Chelsea Anthurium.* 1991. CHARCOAL,
PASTEL, WATERCOLOR, AND OIL ON PAPER,
33 × 24⅝″. THE PACE GALLERY

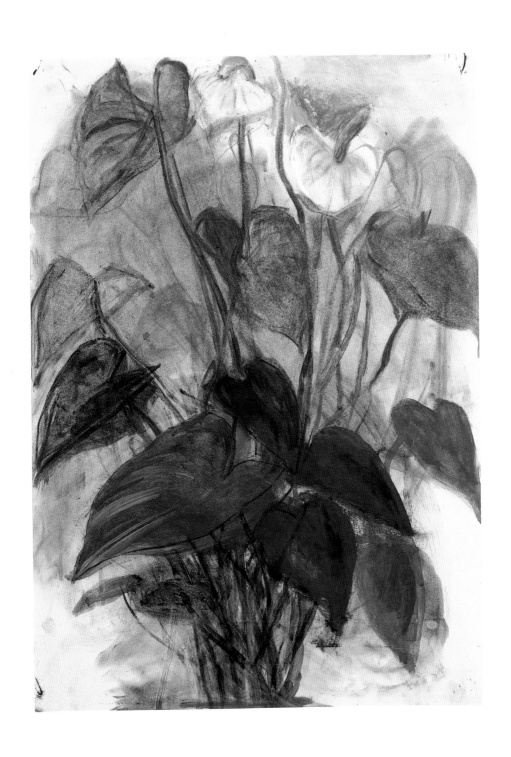

82. *Anthurium on Beige Paper.* 1991. CHARCOAL,
PASTEL, WATERCOLOR, AND OIL ON PAPER,
27 × 19″. THE PACE GALLERY

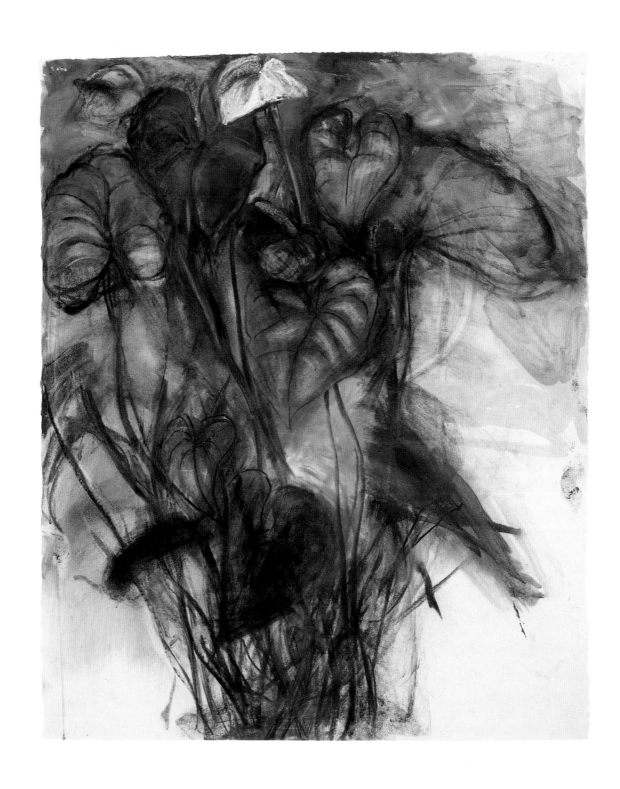

83. *Dark London Drawing.* 1991. CHARCOAL,
WATERCOLOR, PASTEL, AND OIL ON PAPER,
32¾ × 27″. PRIVATE COLLECTION,
NEW YORK CITY

Even when, in desperation, Dine tears out part of a sheet, something can be salvaged from it, and that is part of the challenge. He maintains that he never truly overworks a drawing, because he believes that any unsatisfying mark or surface can be corrected, for example by collaging something over it, as with the roughly pasted central patch of *Chelsea Anthurium,* 1991 (fig. 81). At its most complex, the process of reworking a drawing by adding on to the paper itself, until its form is satisfactory, is likened in some of these botanical images to the task of a gardener, first coaxing a plant to flourish and then cutting it back when the profusion of its growth threatens the beauty and balance of its shape. Dine explains that in drawing *Orchid,* 1991 (fig. 84), with the intention of featuring its blossoms as the keynote of color, "surgical correction" proved necessary: "The blossoms got so complicated that I went back to the leaves and all this foliage, and added lots of bits. I cut it and cut back and added and did what was necessary to make a drawing, that's all."

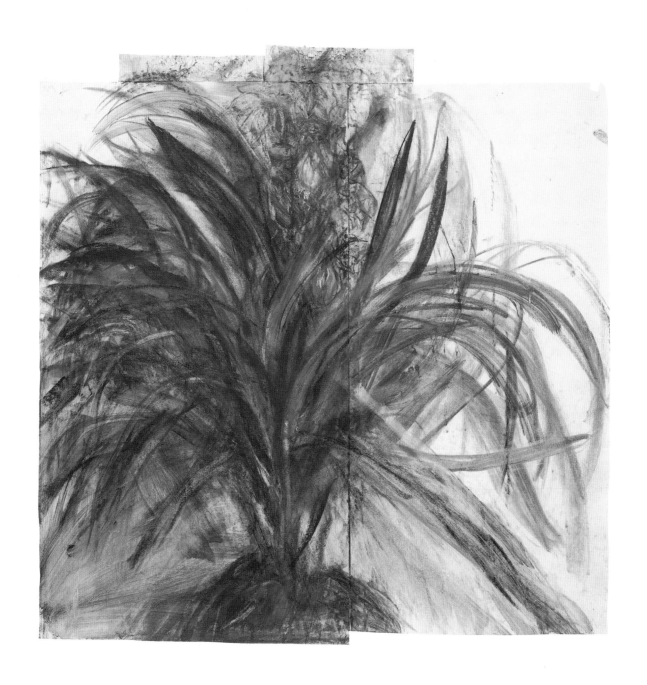

84. *Orchid.* 1991. CHARCOAL, PASTEL,
AND WATERCOLOR ON PAPER, 29½ × 29″.
THE PACE GALLERY

A series of seven Calla Lilies drawn in London in November 1991 (figs. 85–91) provides a vivid display of the variety of ways in which Dine builds up and readjusts his drawings, both by adding on paper of different shapes and sizes and by tearing it back towards the image. He set himself the challenge of producing a drawing a day of the same flowers, but he ended up reworking many of them, concurrently, over a period of a month. The resulting surface is often eccentrically shaped, emphasizing its object quality. Dine removed sections from *Calla Lilies No. 3* (fig. 87), for instance, with the intention of replacing them, but he then decided that he liked the irregular outline of the paper as it was. In others, such as *Calla Lilies No. 6* (fig. 90) and *Calla Lilies No. 7* (fig. 91), he forced himself to stop work at a comparatively early stage in order to preserve the freshness of his response.

In their layering of different mediums in novel and surprising ways, challenging conventional wisdom about the compatibility of contrasting materials, these studies are among Dine's most technically adventurous. *Calla Lilies No. 2* (fig. 86) is perhaps the most extreme in that it consists of marks made in both "dry" mediums—charcoal, pencil, pastel, and chalk—and fluid ones painted on with a brush: watercolor, oil, and enamel. As Dine remarks: "I particularly liked using a lot of industrial paint on these. These really beautiful living plants, to do them in industrial automobile enamels and things like that, I thought was slightly exotic and perverse. But I figured if I could make that work, it would give them another quality."

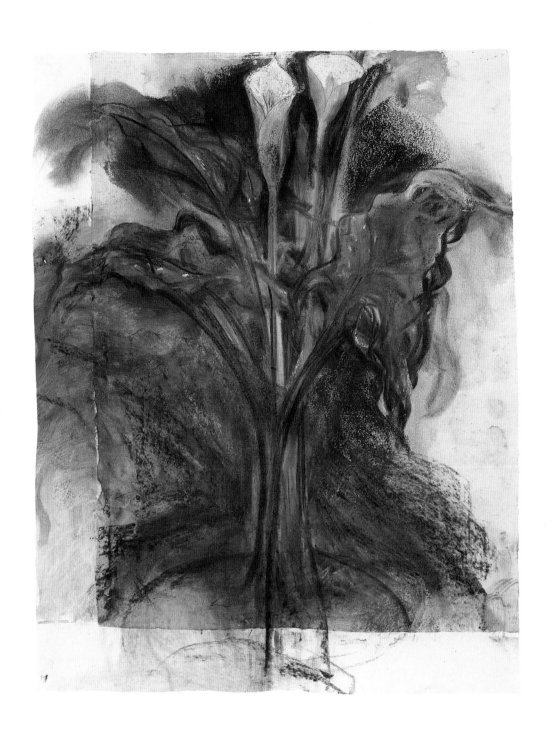

85. *Calla Lilies No. 1.* 1991. CHARCOAL, PASTEL,
AND WATERCOLOR ON PAPER, 25¾ × 20″.
PRIVATE COLLECTION, SWITZERLAND

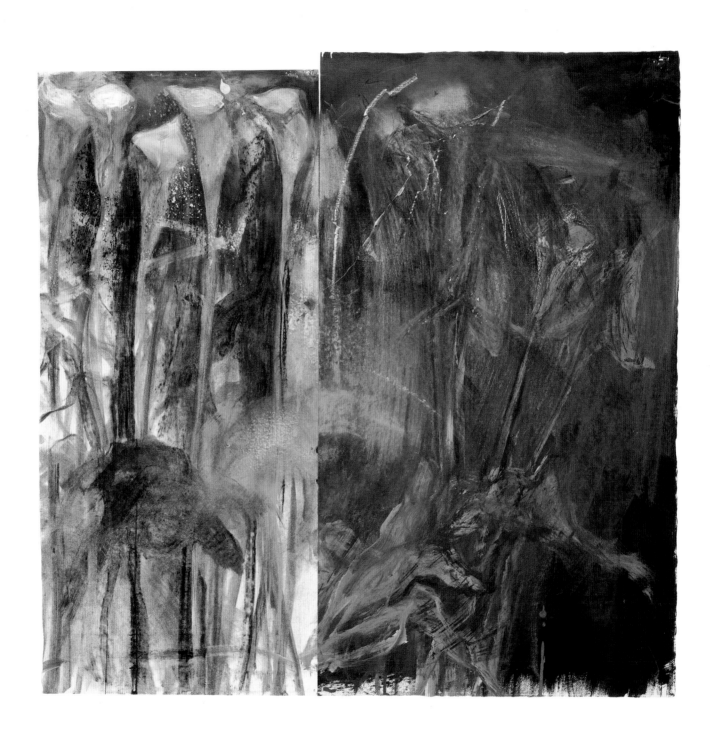

86. *Calla Lilies No. 2.* 1991. CHARCOAL,
PENCIL, PASTEL, CHALK, WATERCOLOR, OIL,
AND ENAMEL ON PAPER, $27\frac{3}{4} \times 28''$.
THE PACE GALLERY

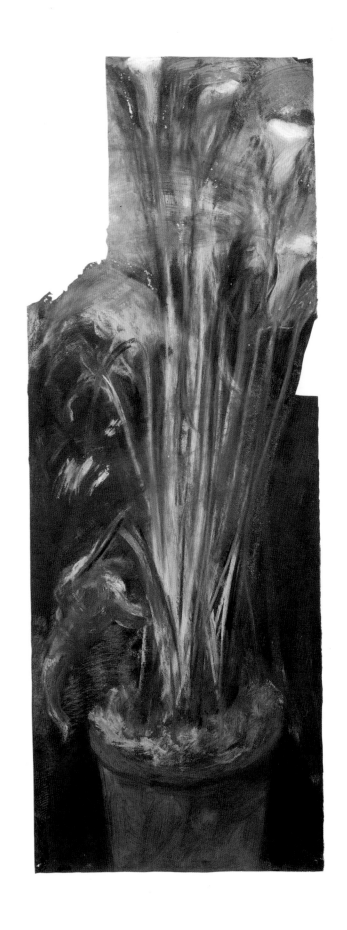

87. *Calla Lilies No. 3.* 1991. CHARCOAL, PASTEL,
OIL, AND PENCIL ON PAPER, $45\frac{3}{4} \times 17''$.
COLLECTION THE ARTIST

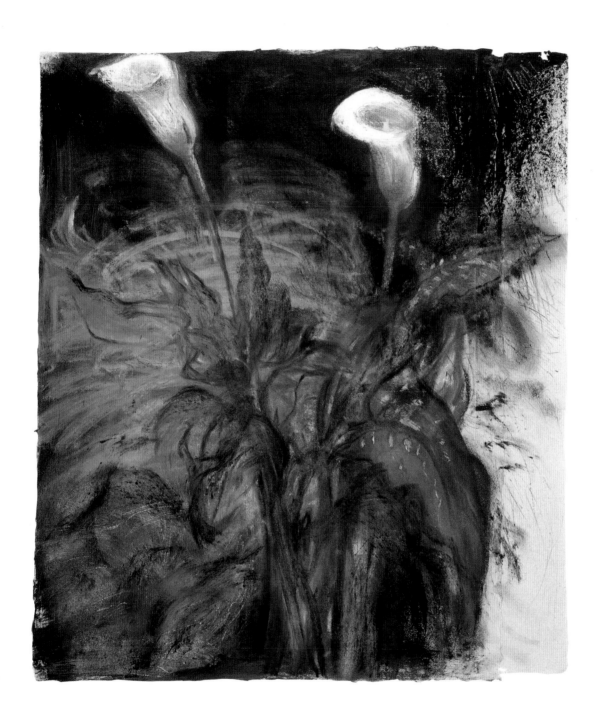

88. *Calla Lilies No. 4.* 1991. CHARCOAL,
PASTEL, AND OIL ON PAPER, 23¾ × 20½".
THE PACE GALLERY

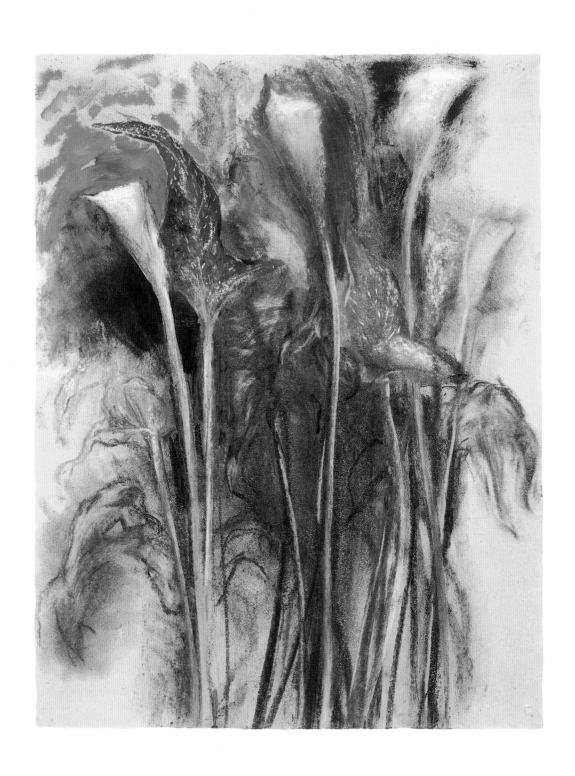

89. *Calla Lilies No.* 5. 1991. CHARCOAL, PASTEL,
WATERCOLOR, AND OIL ON PAPER, 23 × 18″.
COLLECTION NINA DINE

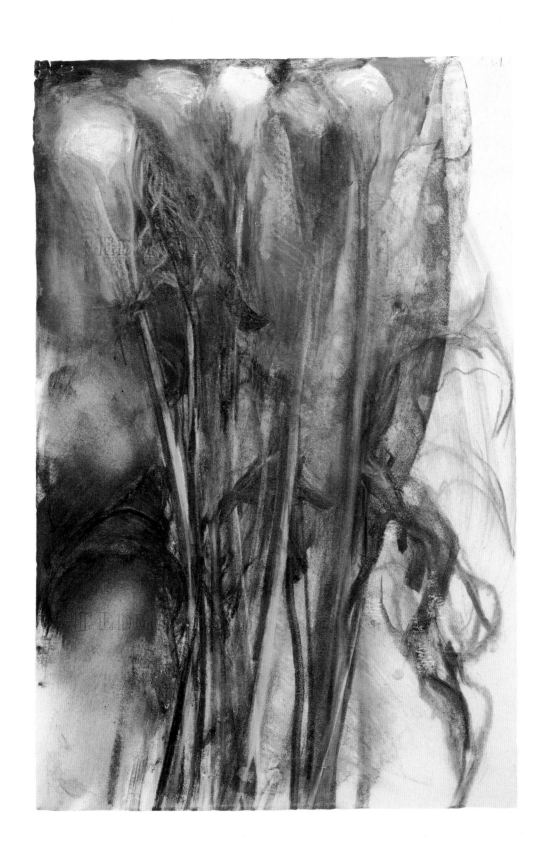

90. *Calla Lilies No. 6.* 1991. CHARCOAL, PASTEL,
WATERCOLOR, AND OIL ON PAPER, 27¾ × 18½″.
THE PACE GALLERY

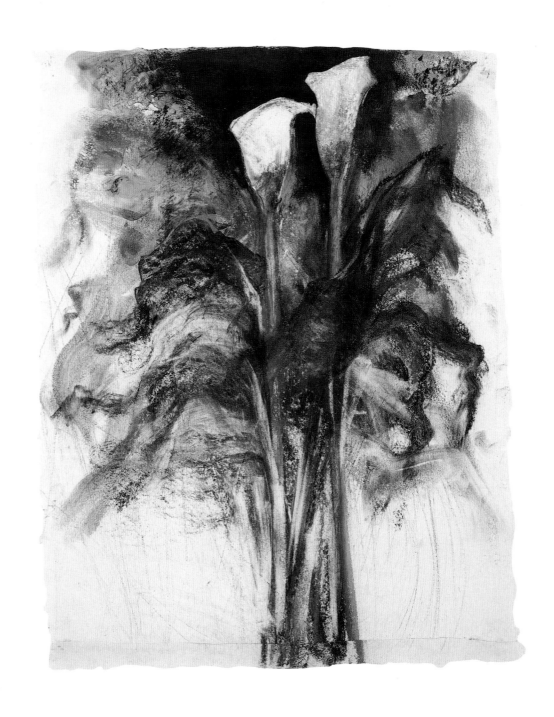

91. *Calla Lilies No. 7.* 1991. CHARCOAL, PASTEL,
WATERCOLOR, AND INK ON PAPER, 22 × 17½".
COLLECTION BLAKE SUMMERS

In *Iris (for Nancy)* (fig. 92), begun in 1982 and worked on again in 1984, the layering of fragments of paper in different colors, including vivid yellows and oranges, adds to the decorative appeal of the image as an object in its own right. Although Dine began, as usual, with a rectangular sheet of paper, as he built it up and redefined its edges by tearing and gluing it back on in different configurations, he gradually altered it so that it took the form of a kimono. It was only later that he began to collect kimonos, which he had seen in museums and in reproductions, and he did not make his first visit to Japan until 1986. What prompted him here to make allusion to these sumptuously decorated items of clothing was a drawing he had made two years earlier but which at that time was still hanging in his bedroom, *The Tree (Kimono)*, 1980 (fig. 93), which he realized looked like a kimono in outline only after completing it.

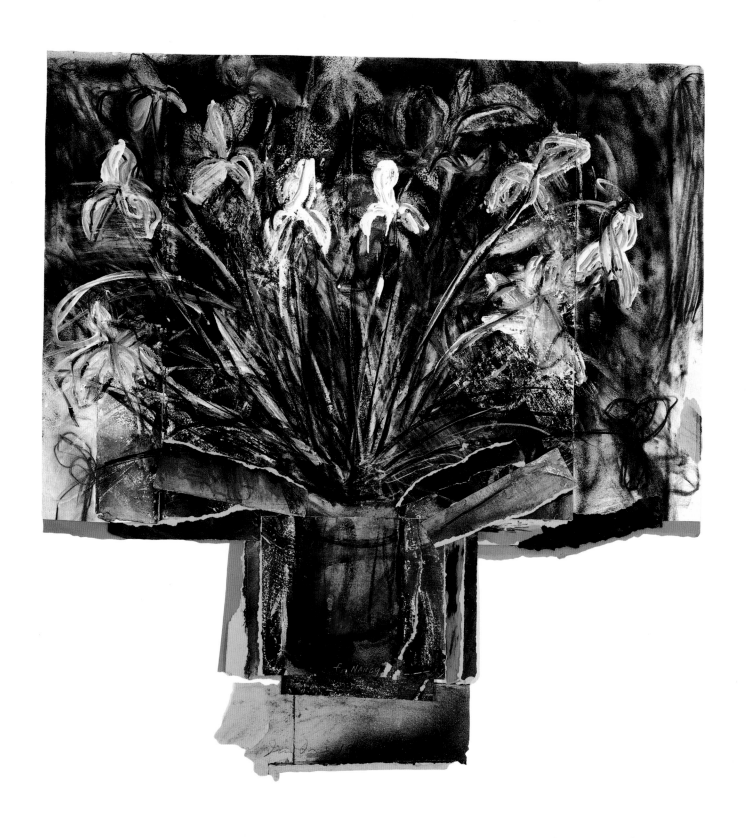

92. *Iris (for Nancy)*. 1982–84. CHARCOAL, OIL
PASTEL, SPRAY PAINT, GOUACHE, AND COLLAGE
ON PAPER, 50 × 48″. PRIVATE COLLECTION,
NEW YORK CITY

Other forms of correcting or reworking used by Dine include erasing or even, in extreme cases, sanding down with electric power tools including the Dremel, a do-it-yourself abrading instrument that he took up in the early 1980s for his woodcuts and etchings as well as his drawings.[12] As always cheerfully unconcerned about what is considered appropriate, he exploits each process for the physical properties that it can bring to the image, as in *Copenhagen (Heracleum)* (fig. 94), a drawing begun in 1982 and reworked over the years, in which some of the most visually assertive marks and highlights—including a diagonally placed series of short striated lines resembling a long screw—have been created by means of such workaday handymen's tools. As Dine recalls:

These plants are everywhere in Denmark in the countryside in the summertime. They're huge, they look like what we call Queen Anne's Lace, except sometimes they're over six feet tall. They're like giant weeds, very beautiful. I had one growing outside the little house I was living in and working in. I made this drawing in black and white on paper that had a sort of clay coating. It was hard to do it. Anyway, I came back with a black-and-white drawing, and I gave it to my wife for a present—for her birthday, I think—but then through the years I worked on it every year. Recently I worked on it again. I scraped out and I added color, I noodled with it; I kept hitting it with a broom to move the color around, and I gave it an atmosphere like a storm. The atmosphere came from all the working through the years. The accumulation of marks and the accumulation of working gave it a sense of weather.

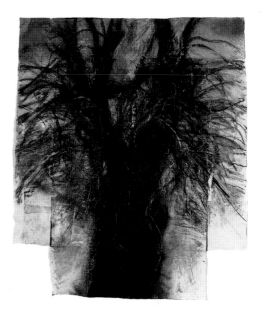

93. *The Tree (Kimono).* 1980. MIXED MEDIUMS ON PAPER, 71 × 60″. MUSEUM OF FINE ARTS, BOSTON

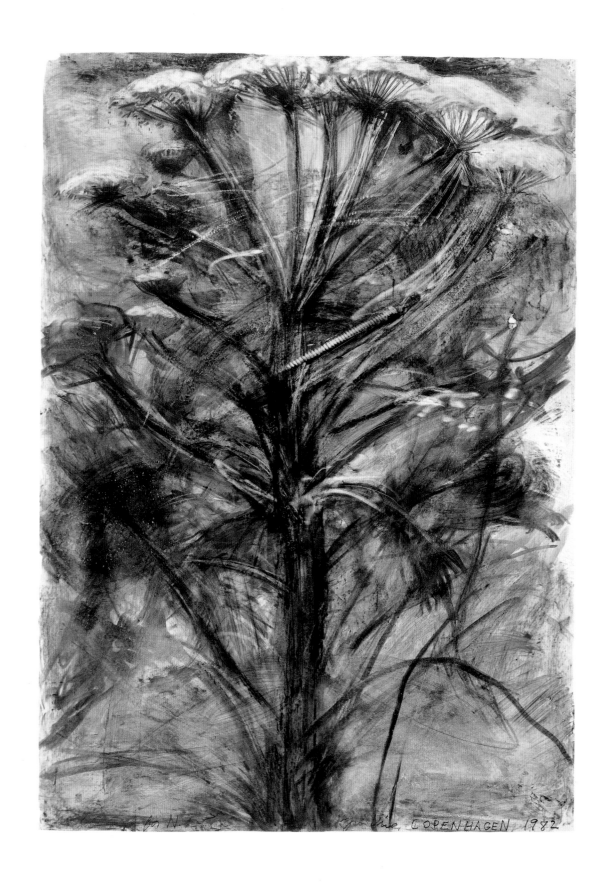

94. *Copenhagen (Heracleum).* 1982. CHARCOAL,
WATERCOLOR, PASTEL, AND SHELLAC ON PAPER,
48 × 34½". COLLECTION NANCY DINE

Two drawings begun during a stay in Paris and reworked in New York, *White Cyclamen,* 1991 (fig. 95), and *White Cyclamen in Paris,* 1991 (fig. 96), were both vigorously revised by procedures of erasing and sanding down. In the former, the rubbing out creates a kind of painterly surface that transforms areas that had been heavily worked into broad sweeps resembling the quick strokes of a large brush; the huge gash made to the sheet near the edge of the saucer, while providing the most extreme evidence of this working back of the surface, also exaggerates the physicality of the object by concentrating attention on its edge. The second of the two drawings was so heavily ground down, creating luminous striations as a shivering atmosphere around the plant, that the paper was too thin and damaged to stand on its own. In pasting it down onto a larger and heavier sheet, Dine created a tonal setting for the image, its spatial qualities brought out by the use of the surrounding white paper as a framing device.

A similar strategy was used by Dine for *London Peonies,* 1991 (fig. 97), in which a proof of one of his etchings of a totally different subject provided a gray background for marks made in charcoal and oil paint. From a distance this looks like a pretty picture of a vase filled with pinkish flowers, but when scrutinized more closely, it has an element of brutality in its rough application of the paint, a token of a healthy lack of concern for the preciousness of the marks. The buds are delineated in a juicy impasto, but elsewhere in the picture, and particularly over the vase, Dine has scraped long gashes into the surface. There is a blatant disregard for propriety here, also, in the way that the marks spill onto the surrounding frame, as if this clean area of paper has been used for wiping paint off the brushes and even—to judge by the fingerprints along the right-hand edge—from the artist's hands.

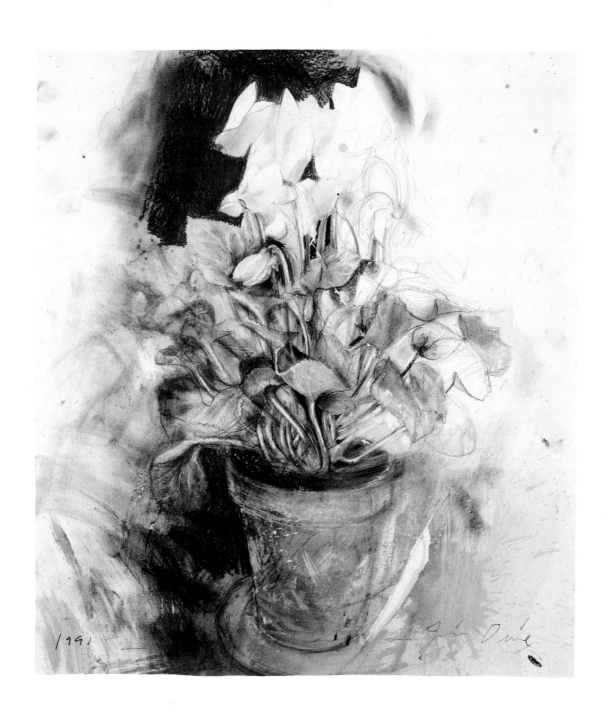

95. *White Cyclamen.* 1991. PENCIL AND
WATERCOLOR ON PAPER, 20¼ × 18″. PRIVATE
COLLECTION, NEW YORK CITY

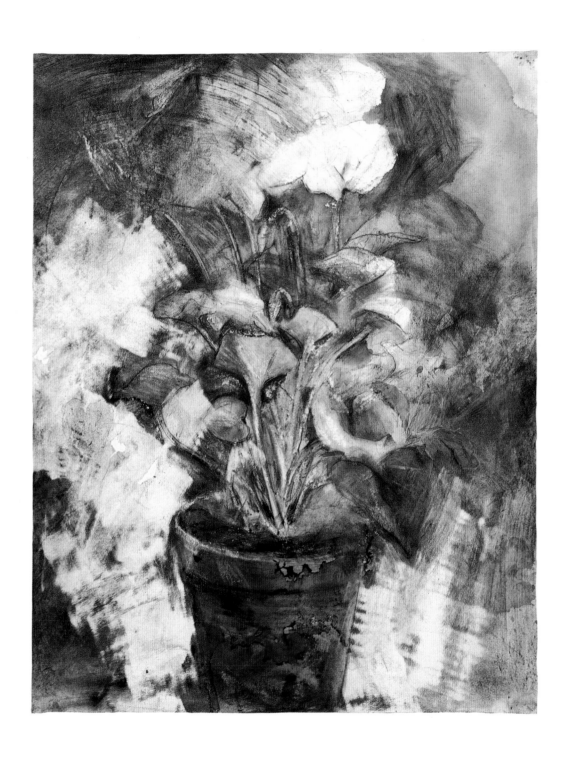

96. *White Cyclamen in Paris.* 1991. WATERCOLOR
AND PENCIL ON PAPER, 22½ × 28″. COLLECTION
ANNE-MARIE McINTYRE

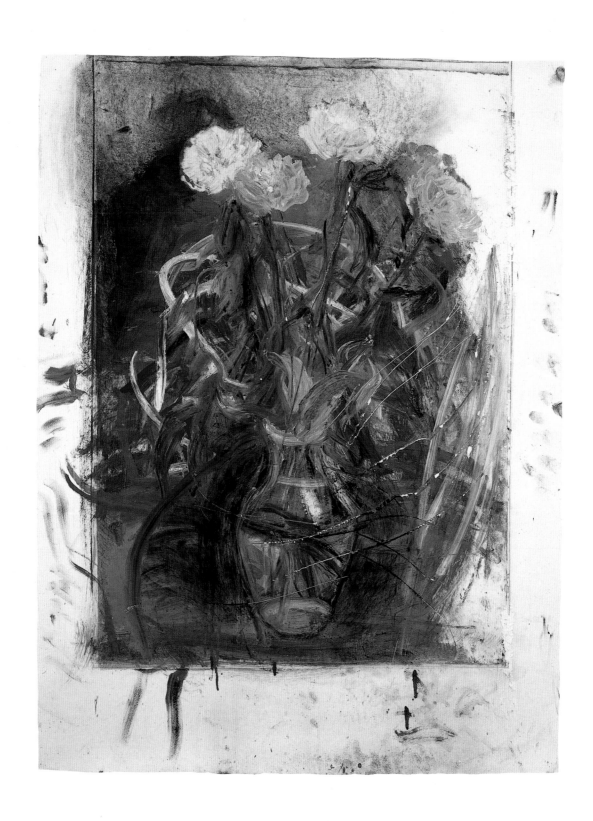

97. *London Peonies.* 1991. OIL AND CHARCOAL
OVER ETCHING ON PAPER, 39 × 29½".
COLLECTION NANCY DINE

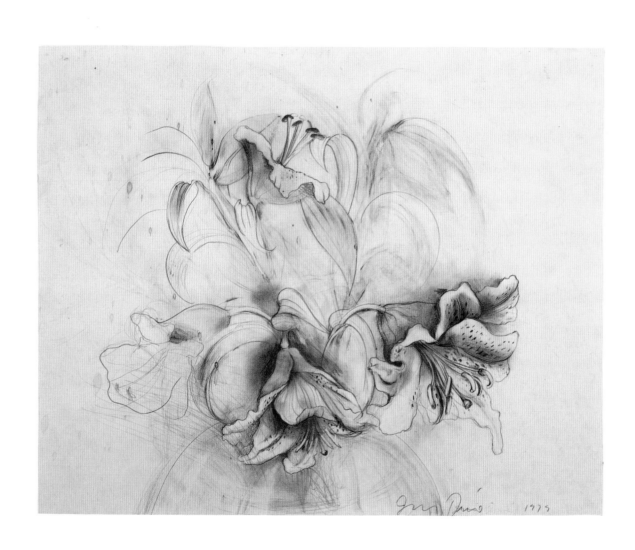

98. *Lilies.* 1979. PENCIL ON PAPER, 17 ½ × 22″.
THE PACE GALLERY

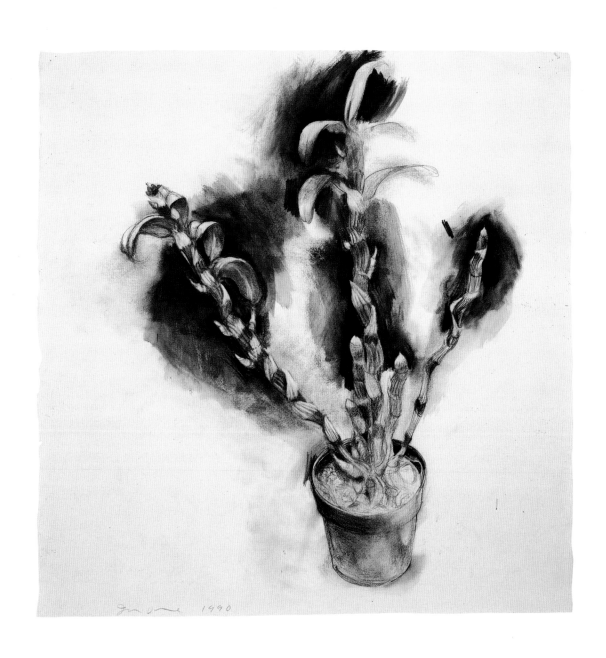

99. *The Orchid.* 1990. PENCIL ON PAPER,
23½ × 22″. COLLECTION THE ARTIST

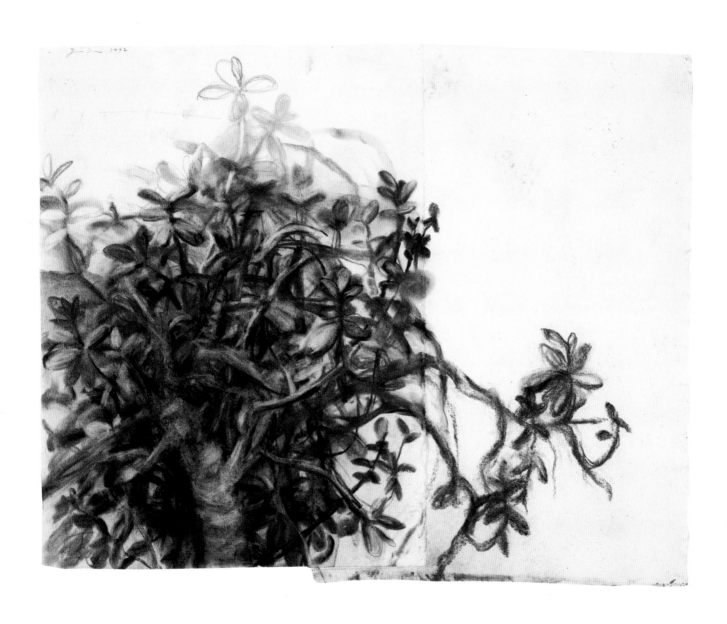

100. *Crassula.* 1992. CHARCOAL ON PAPER,
30¾ × 38″. THE PACE GALLERY

There are two extremes in Dine's art. He remains perhaps best known for the more public, monumental aspect of his work, represented by his largest paintings and by sculptures on a sometimes vast scale, such as his variations on the Venus de Milo. By contrast, the drawings from life, including those of the human figure as well as the nature studies treated here, highlight his contemplative, intimate side. There are variations in tone even in the plant drawings, however, and the most personal of them all tend to be small in scale, closely observed, sober in coloring, and devoid of virtually all signs of rhetoric or showiness in their technique. These are the drawings that Dine has clearly made for himself, in communion with a plant, almost as a form of meditation. This is not to say that they are consistent in style or treatment over the years. On the contrary: it is because they are unwavering in their purpose that they emerge in each case as his response to the character of the plant, as seen in a particular situation and as reflecting his mood at the time, in much the same way as with his sketches of the human figure.

Two drawings made in 1979, *Tulips* (see fig. 24) and *Lilies* (fig. 98), are characterized by wispy lines and by a rhythm of freely flowing forms. Their languorous, fully opened blossoms, like lascivious lips

or genitals spread apart in anticipation of bodily pleasure, verge on the sexually provocative in their eroticism. There is a human aspect, too, to *The Orchid,* 1990 (fig. 99), a condensed and intensely rendered portrait of a potted plant viewed from above; selective shading concentrates attention on the upwardly thrusting movement of its stems towards the light. The dense network of leaves and branches within the main sheet of *Crassula,* 1992 (fig. 100), gives way, in the adjoining panel, to an elegant silhouette traced against the open air like a graceful gesture of arched fingers extended outwards from a bulky torso.

These descriptions of plants as metaphors for human anatomy and emotions verge on the fanciful, and it would be misleading to suggest that in studying them Dine would think of them in terms that distracted from their particular identity. The issue, however, is that he seeks to bring out each plant as itself, rather than as a specimen of a particular class of plants, just as he portrays people and with the same respectful curiosity. There is no disguising his attraction to particular flowers, such as the pots of hyacinths delineated with such tenderness in several drawings made during winter stays in Paris in 1990 and 1991 under a pale wintry light. They are among the most modest in size and the most intimate of all his botanical drawings, a natural result of the fact that the plants themselves are so small and delicate.

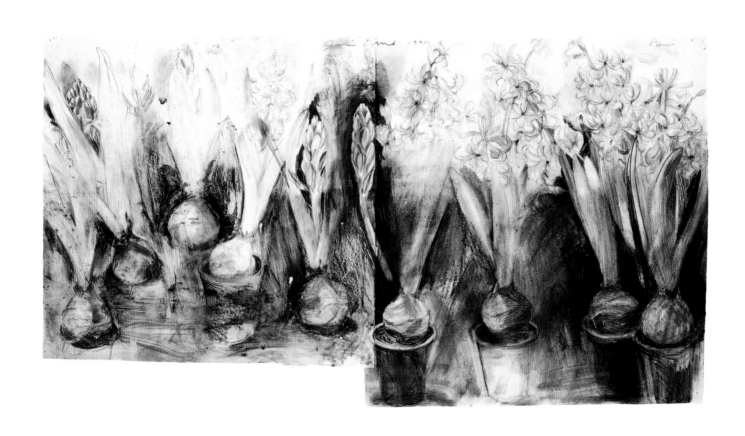

101. *Hyacinth, Paris.* 1991. PENCIL
AND COLORED PENCIL ON PAPER, 15½ × 29″.
THE PACE GALLERY

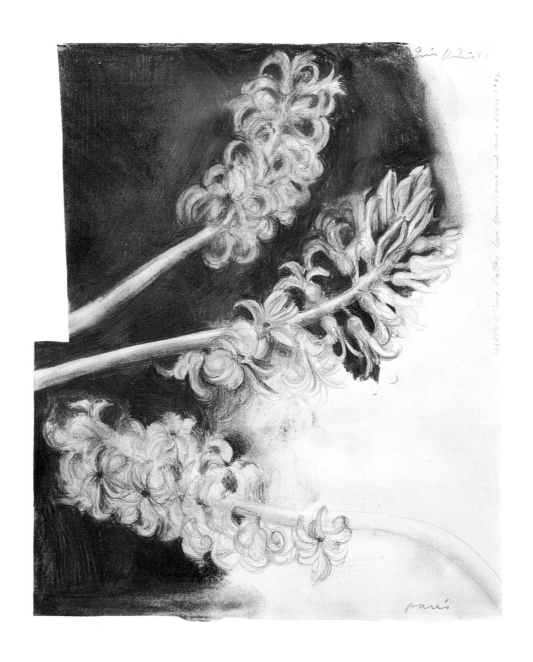

102. *Hyacinth Study.* 1991. PENCIL AND
WATERCOLOR ON PAPER, 11⅛ × 9⅜″.
COLLECTION JOEL GREY

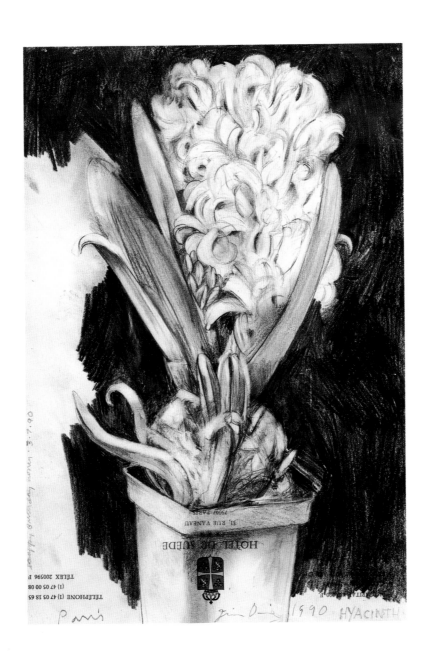

103. *Hyacinth: Hotel de Suède.* 1990. PENCIL ON
PAPER, 11⅝ × 7⅞″. COLLECTION NANCY DINE

Dine took a special pleasure in observing the changes in the hyacinths: "Every afternoon I came in and I drew them in not very nice light, in artificial light, and just kept working at them, trying to see the hyacinth grow, because it kept opening up in the heat of the hotel room." In *Hyacinth, Paris,* 1991 (fig. 101), they are shown in profusion, sprouting from their bulbs and spreading laterally from one sheet onto another, while in *Hyacinth Study,* 1991 (fig. 102), attention is concentrated on the gentle curves of three elongated stems erupting into feathery blossoms against a dramatic background of darkness and light. *Hyacinth: Hotel de Suède,* 1990 (fig. 103), densely rendered on a piece of writing paper, was worked on intensively every day. The printed text of the hotel stationery on which the plant takes form, turned upside down so as not to distract too much from the image, functions like a found object, much as had been the case with his use of words in some of his pictures of the 1960s. It also serves as a souvenir of his stay in the hotel room that served him as both a temporary home and studio, documenting the circumstances in which the drawing was made. "As the plant died and as the hyacinth bloom came out and then died back, it didn't matter, I just kept on going and invented as I went along."

In preparing to draw a particular plant, Dine readies himself with the undisguised enthusiasm of a hunter stalking his quarry. When I visited him at his New York studio in early April 1992, he spoke excitedly of his intention to buy "a really ugly plant," a Euphorbia, that he had seen in a shop nearby: "I think it's from South America," he explained. "It looks like protoplasm, or something, and it's very odd. I'm longing to draw it. I owned one once in the late seventies, but I never got around to drawing it." When I returned two months later, two of his most extraordinary botanical images were more or less complete, one rendered mainly in pencil to capture the complexities of its contours and crevices (fig. 104), the other emphasizing the commanding presence of the bulky mass formed by the superimposition of watercolor and pastel over charcoal (fig. 105). Undoubtedly the most fantastic and grotesque in appearance of all his studies from nature, they are also among the most faithful to the motif: the plant itself was so compelling in its strangeness, and so sculptural in form, that there was no need for him to invent. There was satisfaction enough in capturing the truth to which he was witness. A similar impulse can be detected in two rather painterly studies of cacti executed in the early 1990s: *Cactus,* 1991–93 (fig. 106), in which a mass of threateningly spiky forms emerges from an atmosphere heavy with foreboding, and *Untitled,* 1992 (fig. 107), in which the drooped and withering extensions of a dying cactus—witnessed only a year earlier in the full flush of health (fig. 40)—suggest the writhing movements of an interpretative dancer or the death shudder of a grotesquely shaped and mortally wounded creature.

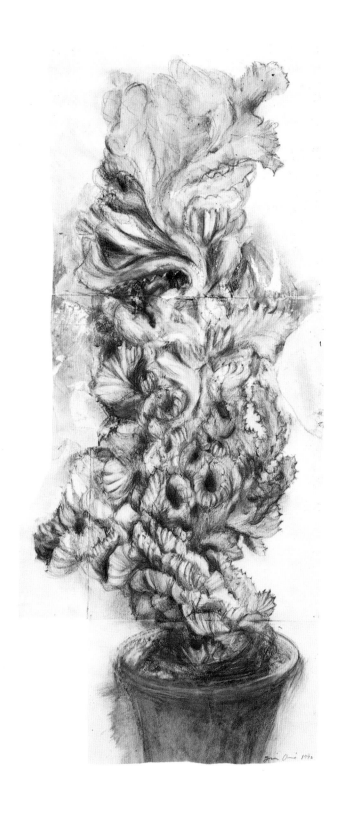

104. *Euphorbia No. 1*. 1992. PENCIL
AND WATERCOLOR ON PAPER, 27⅞ × 12¼″.
COLLECTION THE ARTIST

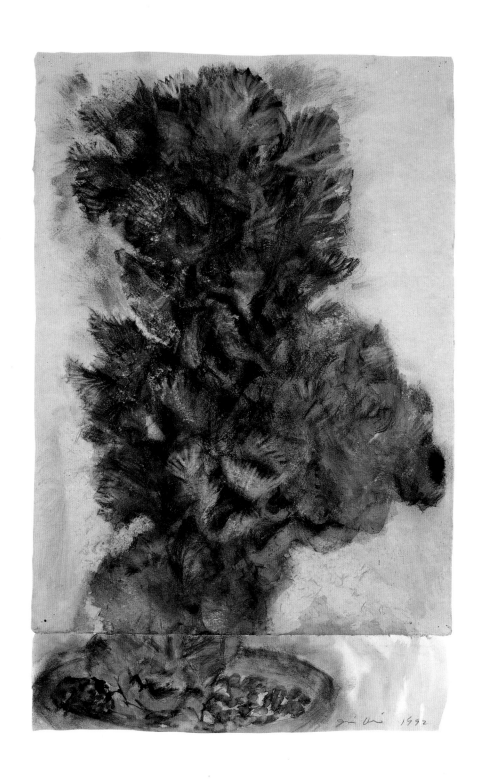

105. *Euphorbia No. 2.* 1992. CHARCOAL, PASTEL,
AND WATERCOLOR ON PAPER, 28 × 18½″.
PRIVATE COLLECTION, NEW YORK CITY

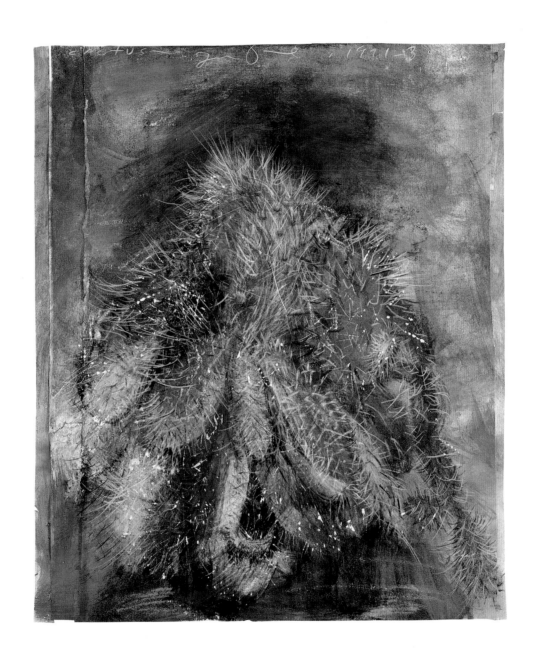

106. *Cactus.* 1991–93. WATERCOLOR,
CHARCOAL, COLORED PENCIL, AND COLLAGE ON
PAPER, 15¾ × 13¼″. THE PACE GALLERY

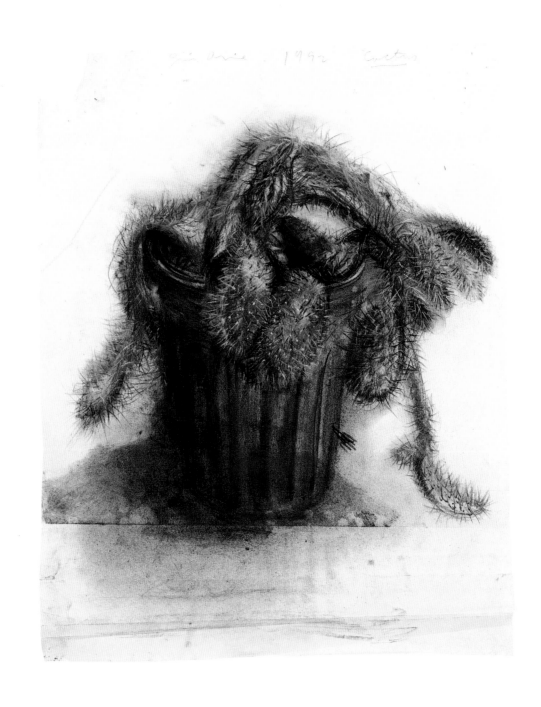

107. *Untitled.* 1992. PENCIL, CHARCOAL, CHALK,
AND COLLAGE ON PAPER, 23 × 18¼″.
COLLECTION THE ARTIST

In contrast to the dourness of the Euphorbia and Cactus drawings and of the plants themselves, there is an ebullient mood and sense of exuberant growth in a sumptuously colored drawing such as *Red Poinsettia,* 1991 (fig. 108), which climaxes in what Dine refers to as "a blowzy red." The character of the plant, as always, conditioned the appearance of the drawing. This is not to say, of course, that because most of Dine's botanical images are of house plants, the drawings are necessarily of a domestic nature. A cultivated plant such as a Delphinium, proudly displayed as an irrepressible skywards growth in charcoal and graphite drawings of 1992 (figs. 109 and 110), appears delicate but no less sturdy in its way than the most vigorous of Dine's drawings of crabapple trees (figs. 111 and 112). Similarly, two large outdoor plants represented full-scale in 1992 in charcoal on man-sized wood panels are each characterized in equal measure by hardiness and by an intricate grace, even though one is an outcrop of

Weeds (fig. 113) and the other a presumably more desirable clump of *Gladiolas* (fig. 114). Conversely, even a Wild British Foxglove (fig. 115), shown as uncontrollable in its growth in a drawing made in 1992—its upward climb to a height of six feet barely contained by an elongated central sheet added to at both ends—is revealed to be standing rather primly in a small pot.

The idea of nature, for many of us, remains associated with exploration into the wild or with the tranquil retreat of a rural landscape untouched by modern industrial life. In revealing to us how he, as a city dweller, is able to enter into the spirit of the cycle of life and the whole of creation through the slightest evidence of a humble potted plant, Dine in his botanical drawings opens our eyes to mysteries to which we can all succumb.

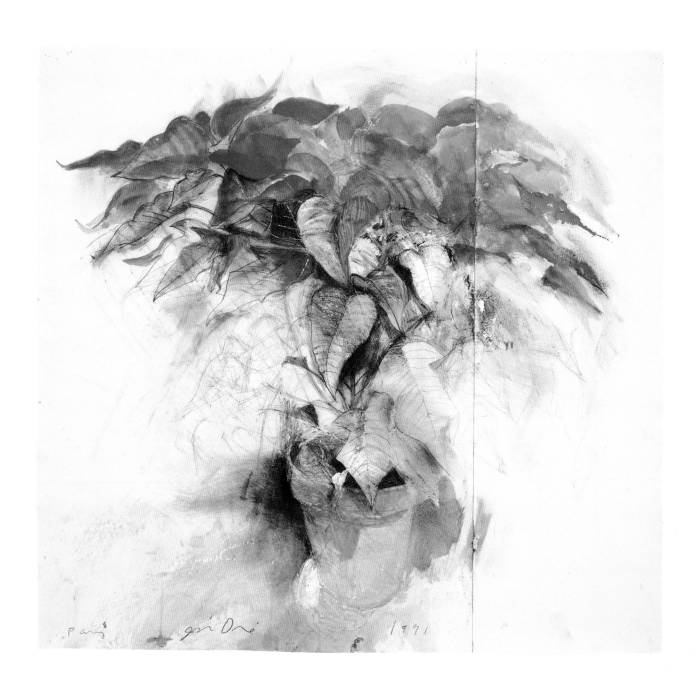

108. *Red Poinsettia.* 1991. WATERCOLOR,
PASTEL, AND PENCIL ON PAPER, $36 \times 24''$.
COLLECTION EMILY DINE

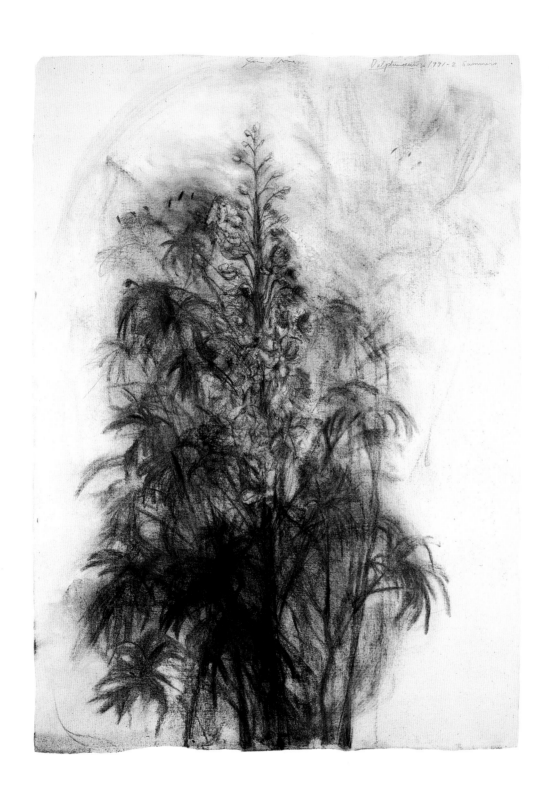

109. *Delphinium.* 1991–92. CHARCOAL
AND GRAPHITE ON PAPER, 30½ × 22″.
COLLECTION NANCY DINE

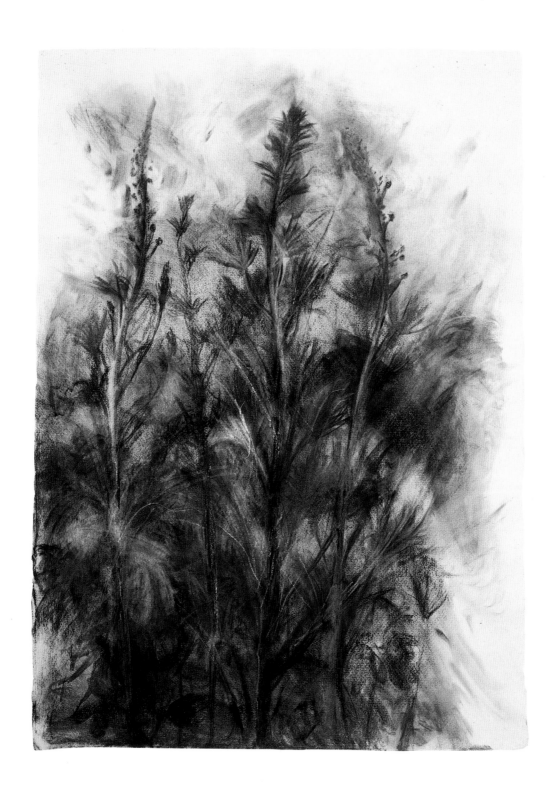

110. *Delphinium II*. 1992. CHARCOAL
AND GRAPHITE ON PAPER, 31¾ × 23¼″.
THE PACE GALLERY

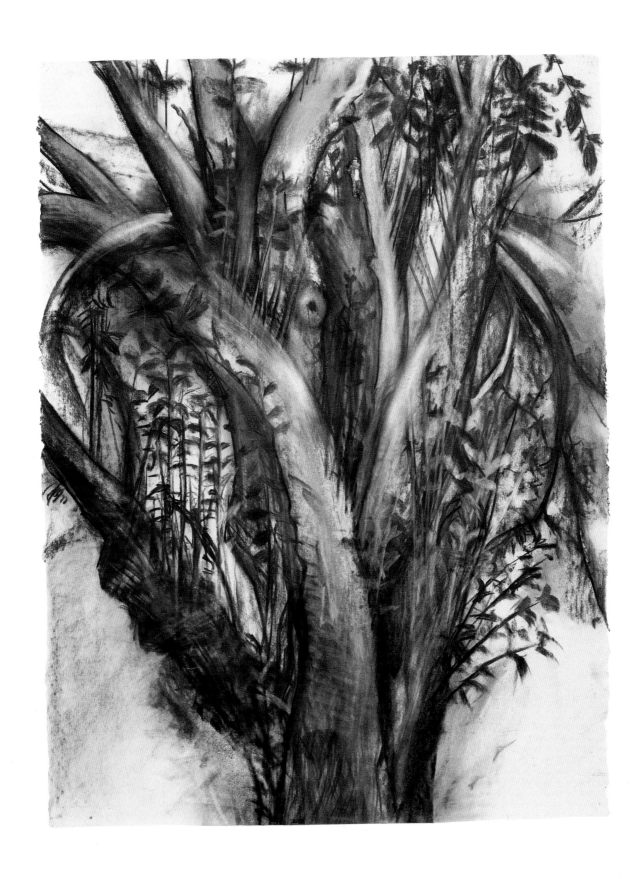

111. *Crabapple Tree No. 2.* 1986–87. CHARCOAL
ON PAPER, 59½ × 40". LOCATION UNKNOWN

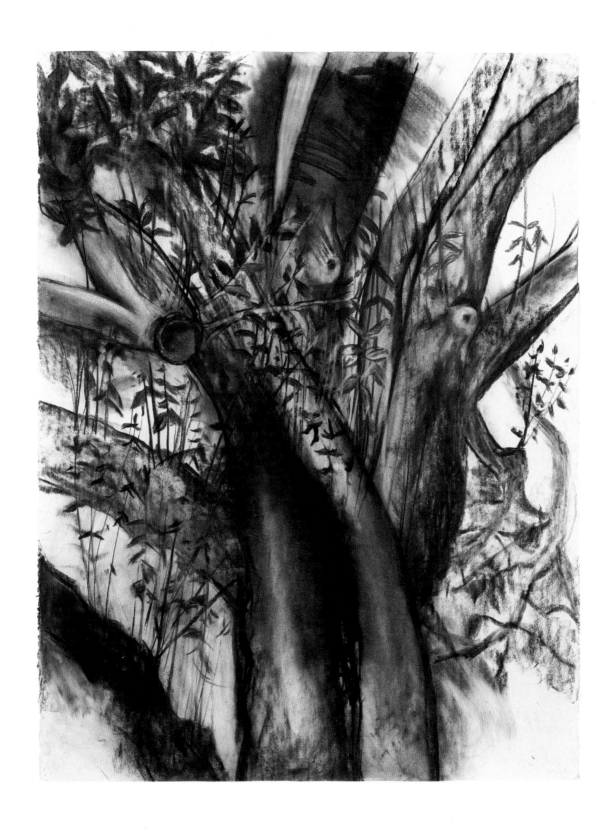

112. *Crabapple Tree No. 3.* 1986–87. CHARCOAL
ON PAPER, 49¾ × 38″. BÔRAS KONSTMUSEUM,
SWEDEN

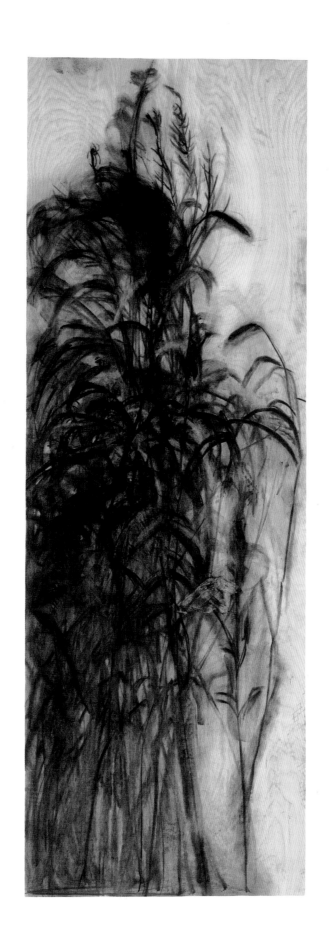

113. *Weeds.* 1992. CHARCOAL ON WOOD PANEL,
75 × 26″. PRIVATE COLLECTION, NEW YORK CITY

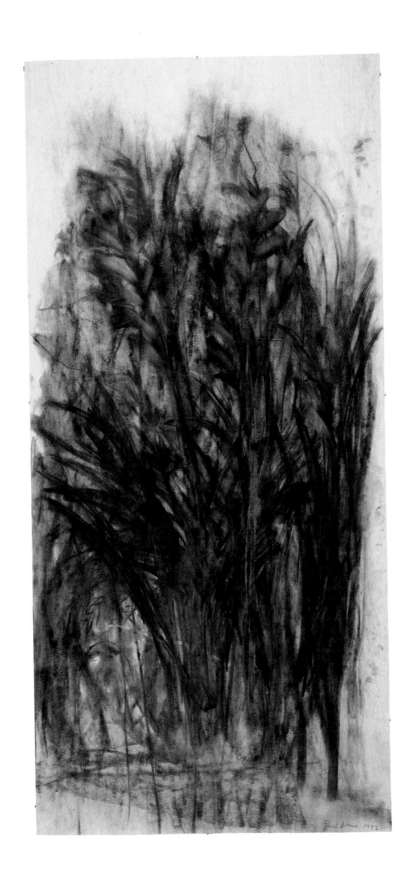

114. *Gladiolas.* 1992. CHARCOAL ON WOOD
PANEL, 54¾ × 26″. PRIVATE COLLECTION,
NEW YORK CITY

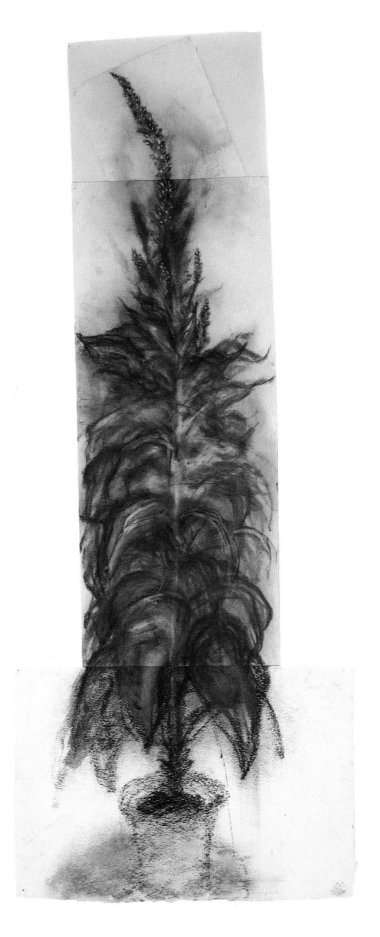

115. *Wild British Foxglove.* 1992. CHARCOAL,
CONTÉ CRAYON, AND WATERCOLOR ON PAPER,
78¼ × 32″. THE PACE GALLERY

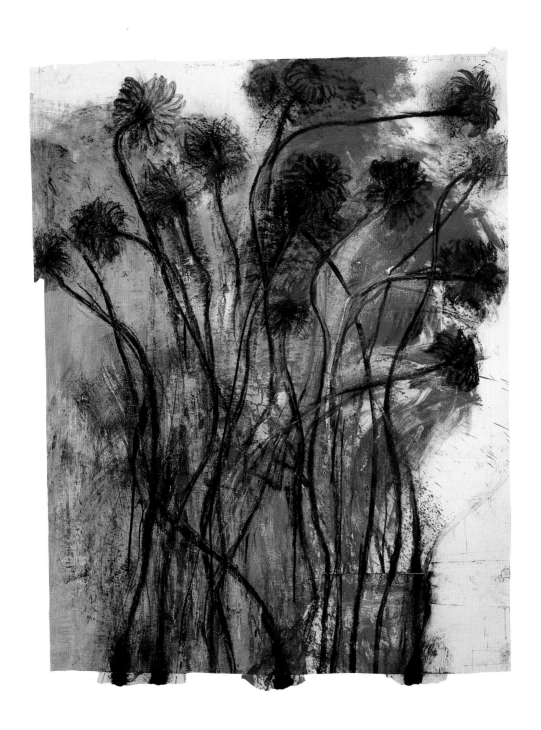

1. All quotations from the artist, unless otherwise indicated, are from interviews with the author in London on November 20, 1991, and February 17, 1992, and in New York on April 2, 1992.

2. Interview with Thomas Krens, July and August 1976, in *Jim Dine: Prints* (New York: Harper & Row, 1977), p. 16.

3. Dine first met Kitaj, who had moved to England in 1958 to continue his training under the terms of the GI Bill, in January 1965 in New York. They shared an exhibition at the Cincinnati Art Museum in 1973, writing catalogue essays in praise of each other's work, and Kitaj wrote a passionate defense of Dine's figure drawings when they were first shown in force in 1977 (for the exhibition catalogue *Jim Dine: Works on Paper 1975–1976*, Waddington and Tooth Galleries II, London, April 26–May 21, 1977). See Dine's comments on Kitaj in the interview with Krens, op. cit., pp. 23–24.

4. See the comments he made in 1983 in interviews with Constance W. Glenn, published in her *Jim Dine Drawings* (New York: Harry N. Abrams, 1985), pp. 38–39 and 49–51.

5. Dine's painting *The Death at South Kensington (October)*, 1983, was painted in memory of McEwen. Dine recalls: "It was shocking, the whole thing was shocking. It was a great loss to me . . . because he was somebody I spoke with all the time about everything, and he understood exactly what I was saying, even though he couldn't make it work for himself sometimes. We were very *simpático*." Dine's wife, Nancy, was also very close to McEwen and conducted a few interviews with him about his work in the final stages of his illness, in the hope of publishing a book about his work.

6. Rory McEwen, "An Autobiographical Fragment," in *Rory McEwen: The Botanical Paintings* (exhibition catalogue, Royal Botanic Garden, Edinburgh, August 13–October 2, 1988, in association with the Serpentine Gallery, London), p. 3.

7. Although Dine has only rarely made drawings of plants from photographs, he has looked at a wide range of photographic images of plants by Irving Penn, Edward Weston, Karl Blossfeldt, and others. He formed a collection of about thirty notable photographs in the 1960s, including one "ravishing" image by Eugène Atget of an apple orchard in blossom.

8. For reproductions of this group of drawings, and Dine's comments about them, see Glenn, op. cit., pp. 43–46 and plates 149–53.

9. Susie Hennessy, "A Conversation with Jim Dine," *Art Journal*, Spring 1980, quoted in Glenn, op. cit., p. 206.

10. For an account of this series, see Ellen G. D'Oench and Jean E. Feinberg, *Jim Dine Prints 1977–1985* (New York: Harper & Row, 1986), p. 122 and catalogue numbers 131–36, 148, and 176.

11. See ibid., p. 96 and catalogue numbers 73–78.

12. See ibid., pp. 27–28, for a reproduction of a Dremel and its attachments and for a discussion of its use in Dine's prints.

Gerbera Daisy. 1993. CHARCOAL, OIL, AND ENAMEL WITH COLLAGE ON PAPER, 47½ × 37¼″. COLLECTION NANCY DINE

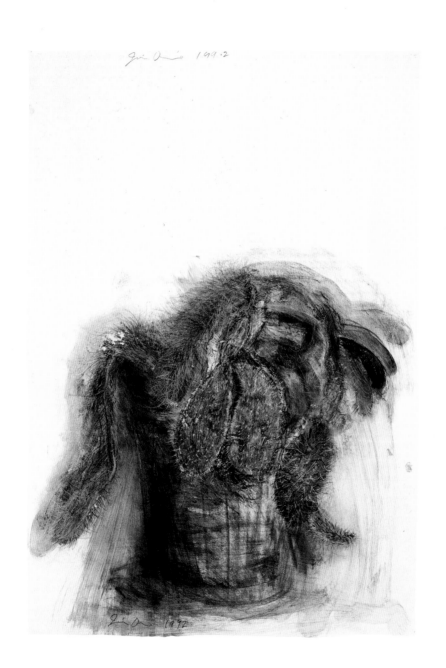

ARTICLES AND INTERVIEWS

Calas, Nicolas. "Jim Dine: Tools and Myth." *Metro* 7, 1962: 76–79.

Jouffroy, Alain. "Jim Dine: Through the Telescope." *Metro* 7, 1962: 72–75.

Swenson, Gene R. "What Is Pop Art? Part I." *ARTnews* 62, November 1963: 24–25, 61–62.

Solomon, Alan R. "Jim Dine and the Psychology of the New Art." *Art International* 8, October 1964: 52–56.

Kozloff, Max. "The Honest Elusiveness of Jim Dine." *Artforum* 3, December 1964: 36–40.

Alloway, Lawrence. "Apropos of Jim Dine." *Allen Memorial Art Museum Bulletin* [Oberlin College], Fall 1965: 21–24.

Johnson, Ellen H. "Jim Dine and Jasper Johns." *Art and Literature*, Autumn 1965: 128–40.

Smith, Brydon. "Jim Dine: Magic and Reality." *Canadian Art* 23, January 1966: 30–34.

Fraser, Robert. "Dining with Jim." *Art and Artists* 1, September 1966: 49–53.

Koch, Kenneth. "Test in Art." *ARTnews* 65, October 1966: 54–57.

Gruen, John. "All Right, Jim Dine, Talk!" *World Journal Tribune Sunday Magazine*, November 20, 1966: 34.

Shapiro, David. "Jim Dine's Life-in-Progress." *ARTnews* 69, March 1970: 42–46.

Towle, Tony. "Notes on Jim Dine's Lithographs." *Studio International* 129, no. 921 (April 1970): 165–68.

Tomkins, Calvin. "Profiles." *The New Yorker* 52, no. 16 (June 7, 1976): 42–76.

Robinson, Frank, and Michael Shapiro. "Jim Dine at Forty." *Print Collector's Newsletter* 7, no. 4 (September/October 1976): 101–5.

Goldman, Judith. "Jim Dine's Robes: The Apparel of Concealment." *Arts Magazine* 51, March 1977: 128–29.

Gruen, John. "Jim Dine and the Life of Objects." *ARTnews* 76, September 1977: 38–42.

Ashbery, John, "New Dine in Old Bottles." *New York Magazine* 11, May 22, 1978: 107–9.

Hennessy, Susie. "A Conversation with Jim Dine." *Art Journal* 39, no. 3 (Spring 1980): 168–75.

Glenn, Constance W. "Artist's Dialogue: A Conversation with Jim Dine." *Architectural Digest*, November 1982: 74, 78, 82.

Dannatt, Adrian. "Jim Dine: From My Heart to My Hand." *Flash Art*, March/April 1991: 88–93.

BACKGROUND BOOKS

Amaya, Mario. *Pop as Art: A Survey of the New Super-Realism.* London: Studio Vista, 1965.

Hansen, Al. *A Primer of Happenings and Time-Space Art.* New York and Paris: Something Else Press, 1965.

Kirby, Michael. *Happenings: An Illustrated Anthology.* New York: E. P. Dutton, 1965.

Untitled. 1992. CHARCOAL, PENCIL, PASTEL, AND CHALK ON PAPER, 33 × 23″. COLLECTION THE ARTIST

Rublowsky, John. *Pop Art.* New York: Basic Books, 1965.

Kaprow, Allan. *Assemblage, Environments, and Happenings.* New York: Harry N. Abrams, 1966.

Lippard, Lucy R. *Pop Art.* New York: Frederick A. Praeger, 1966.

Calas, Nicolas. *Art in the Age of Risk.* New York: E. P. Dutton, 1968.

Russell, John, and Suzi Gablik. *Pop Art Redefined.* London: Thames and Hudson, 1969.

Calas, Nicolas, and Elena Calas. *Icons and Images of the Sixties.* New York: E. P. Dutton, 1971.

Alloway, Lawrence. *Topics in American Art Since 1945.* New York: W. W. Norton, 1975.

Codognato, Attilio, ed. *Pop Art: evoluzione di una generazione.* Milan: Electa, 1980.

Mahsun, Carol Anne. *Pop Art and the Critics.* Ann Arbor: UMI Research Press, 1987.

Sandler, Irving. *American Art of the 1960s.* New York: Harper & Row, 1988.

Livingstone, Marco. *Pop Art: A Continuing History.* New York: Harry N. Abrams, 1990.

Osterwold, Tilman. *Pop Art.* Cologne: Benedikt Taschen, 1990.

Elderfield, John, ed. *American Art of the 1960s.* Studies in Modern Art, 1. New York: The Museum of Modern Art, 1991.

CATALOGUES OF SELECTED GROUP EXHIBITIONS

Martha Jackson Gallery, New York. *New Forms—New Media I.* Essays by Lawrence Alloway and Allan Kaprow, 1960.

————. *New Forms—New Media II.* 1960.

The Museum of Modern Art, New York. *The Art of Assemblage.* Text by William Seitz, 1961.

Sidney Janis Gallery, New York. *New Realists.* Preface by John Ashbery; excerpts from *A Metamorphosis in Nature,* by Pierre Restany; essay by Sidney Janis, 1962.

The Buffalo Fine Arts Academy, Albright-Knox Gallery. *Mixed Media and Pop Art.* Foreword by Gordon M. Smith, 1963.

William Rockhill Nelson Gallery of Art, Atkins Museum of Fine Arts, Kansas City. *Popular Art.* Text by Ralph Coe, 1963.

Gallery of Modern Art, Washington, D.C. *The Popular Image.* Essay by Alan R. Solomon, 1963.

The Solomon R. Guggenheim Museum, New York. *Six Painters and the Object.* Essay by Lawrence Alloway, 1963.

————. *American Drawings.* Introduction by Lawrence Alloway, 1964.

Stedelijk Museum, Amsterdam. *American Pop Art.* Essay by Alan R. Solomon, 1964.

Moderna Museet, Stockholm. *Amerikansk Pop-Konst.* Texts by Alan R. Solomon and Billy Klüver, 1964.

Akademie der Künste, Berlin. *Neue Realisten und Pop Art.* Essay by Werner Hofmann, 1964.

The Solomon R. Guggenheim Museum, New York. *Eleven from the Reuben Gallery.* Introduction by Lawrence Alloway, 1965.

Art Gallery of Ontario, Toronto. *Dine, Oldenburg, Segal.* Preface by Brydon Smith; essay by Alan R. Solomon, 1967.

Cincinnati Art Museum, Cincinnati. *Dine—Kitaj.* Essays by R. J. Boyle, Jim Dine, and R. B. Kitaj, 1973.

Whitney Museum of American Art, New York. *Blam! The Explosion of Pop, Minimalism, and Performance 1958–1964.* Text by Barbara Haskell, 1984. In association with W. W. Norton, New York and London.

Art Gallery of New South Wales, Sydney. *Pop Art 1955–70.* Text by Henry Geldzahler, 1985.

Royal Academy of Arts, London. *Pop Art.* Edited by Marco Livingstone, 1991. In association with Weidenfeld & Nicolson, London, and Rizzoli, New York. Rev. eds. published by Museum Ludwig, Cologne; Centro de Arte Reina Sofía, Madrid; Montreal Museum of Fine Arts, 1992.

CATALOGUES OF SOLO EXHIBITIONS

Sidney Janis Gallery, New York. *Jim Dine.* Essay by Oyvind Fahlström, 1963.

Galerie Ileana Sonnabend, Paris. *Jim Dine.* Texts by Alain Jouffroy, Gillo Dorfles, Lawrence Alloway, and Nicolas Calas, 1963.

The Museum of Modern Art, New York. *Jim Dine: Designs for "A Midsummer Night's Dream."* Introduction by Virginia Allen, 1968.

Kestner-Gesellschaft, Hanover. *Jim Dine.* Essay by Wieland Schmied, 1970.

Whitney Museum of American Art, New York. *Jim Dine.* Essay by John Gordon, 1970.

Galerie Mikro, Berlin. *Jim Dine: Complete Graphics (1960–69).* Essays by John Russell, Tony Towle, and Wieland Schmied, 1970.

Kunsthalle, Bern. *Jim Dine.* Introduction by Carlo Huber; essay by Christopher Finch; statement by Jim Dine, 1971.

Museum Boymans-van Beuningen, Rotterdam. *Jim Dine; Schilderijen, Aquarellen, Objecten en het Complet Grafische Oeuvre.* Text by Christopher Finch, 1971.

Waddington and Tooth Galleries II, London. *Jim Dine: Works on Paper 1975–1976.* Essay by R. B. Kitaj, 1977.

The Art Institute of Chicago. *Nancy Outside in July: Etchings by Jim Dine.* Text by Clifford Ackley; statements by Jim Dine and Nancy Dine, 1983.

The Pace Gallery, New York. *Jim Dine: Sculpture and Drawings.* Essay by Michael E. Shapiro, 1984.

Galerie Baudoin Lebon, Paris. *Jim Dine: une exposition pour Paris.* Essay by Anne Dagbert, 1986.

Waddington Graphics, London. *Jim Dine: Rise Up, Solitude! Prints 1985–86.* Essay and interview by Marco Livingstone, 1986.

Galleria d'arte moderna di Ca' Pesaro, Venice. *Jim Dine.* Essays by Attilio Codognato, David Shapiro, Carter Ratcliff, and Marco Livingstone, 1988.

The Contemporary Arts Center, Cincinnati. *Jim Dine Drawings 1970–1987.* Text by Sarah Rogers-Lafferty and E. A. Carmean, 1988.

The Pace Gallery, New York. *Jim Dine: New Paintings.* Essay by Carter Ratcliff, 1988.

Waddington Galleries, London. *Jim Dine.* Essay by Demetrio Paparoni, 1989.

Waddington Graphics, London. *Jim Dine: Youth and the Maiden.* Essay by Konrad Oberhuber, 1989.

Isetan Museum of Art, Tokyo. *Jim Dine.* Text by Marco Livingstone, 1990.

The Pace Gallery, New York. *Jim Dine: Drawings.* 1990.

Glyptothek am Königsplatz, Munich. *Jim Dine in der Glyptothek.* Preface by Klaus Vierneisel; essay by Wieland Schmied; interview by Wilhelm Warning, 1990.

The Pace Gallery, New York. *Jim Dine: New Paintings and Sculpture.* Interview by Martin Friedman, 1991.

Galerie Beaubourg, Paris. *Jim Dine: Trembling for Color.* Essay by Jean-Louis Schefer, 1991.

Waddington Graphics, London. *Jim Dine: The Four Continents.* Essay by Marco Livingstone, 1993.

The Pace Gallery, New York. *Jim Dine: Ape & Cat.* 1993.

MONOGRAPHS

Jim Dine: Prints 1970–1977: Catalogue raisonné with conversation between Jim Dine and Thomas Krens. Williams College, Williamstown, Mass., in association with Harper & Row, New York, 1977.

Glenn, Constance W. *Jim Dine, Figure Drawings 1975–1979.* New York: Harper & Row, 1979.

Shapiro, David. *Jim Dine: Painting What One Is.* New York: Harry N. Abrams, 1981.

Jim Dine: Five Themes. Text by W. J. Beal, with contributions by Robert Creeley, Jim Dine, and Martin Friedman. Minneapolis: The Walker Art Center, in association with Abbeville Press, New York, 1984.

Glenn, Constance W. *Jim Dine Drawings.* New York: Harry N. Abrams, 1985.

Jim Dine Prints 1977–1985. Catalogue raisonné with essays by Ellen G. D'Oench and Jean E. Feinberg. Middletown, Conn.: Davison Art Center and the Ezra and Cecile Zilkha Gallery, Wesleyan University, in association with Harper & Row, New York, 1986.

Jim Dine: Drawing from the Glyptothek. Essays by Jim Dine, Ruth E. Fine, and Stephen Fleischman. Madison Art Center, Wisc., in association with Hudson Hills Press, New York, 1993.

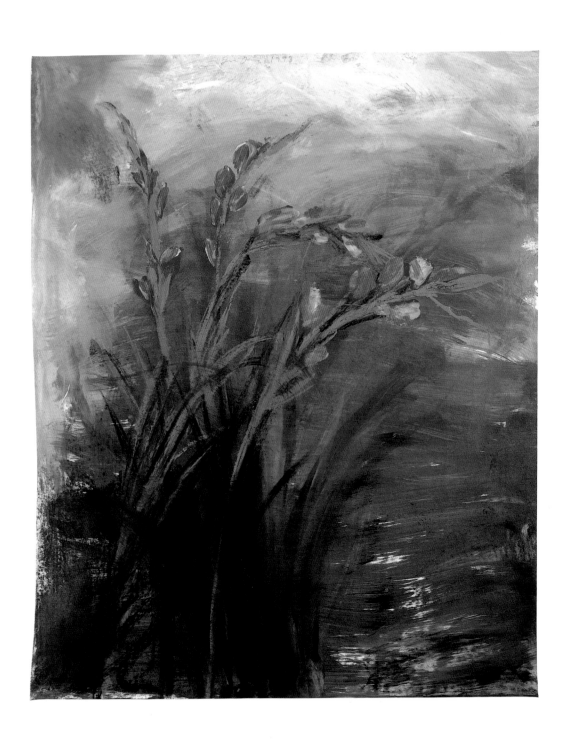

Red Gladiolas. 1993. CHARCOAL, OIL,
AND ENAMEL ON PAPER, 49¼ × 40½″.
COLLECTION NANCY DINE

yellow center

English
Daisy

white petals

Bellis
perennis

April